PROHIBITION

IN

DALLAS
&FORT
WORTH

BLIND TIGERS, BOOTLEGGERS
AND BATHTUB GIN

Rita Cook and Jeffrey Yarbrough

Foreword by Jason Kosmas / Photos by Kevin Marple

AMERICAN PALATE

Published by American Palate
A Division of The History Press
Charleston, SC 29403
www.historypress.net

Cover image: Campisis Saloon. *Whitney Filloon from Eater's*.

All photos by Kevin Marple unless otherwise noted.

First published 2013

Manufactured in the United States

ISBN 978.1.60949.972.3

Library of Congress CIP data applied for.

CONTENTS

FOREWORD

J ust over three years ago, I moved to Dallas, Texas, from New York City, where I earned a great reputation as a man who could make a drink. In the late 1990s, I tutored under cocktail maven Dale Degroff before opening the cocktail den Employees Only, which would later go on to win the title of Best Cocktail Bar in the World at Tales of the Cocktail. Seeking greener pastures for family life, I made the move to Dallas in 2009. I knew little about the town, and it knew less of me. The first thing I became fascinated with concerning the drinking culture of Texas was the juxtaposition of how much alcoholic beverages were cherished and how many "dry" counties still existed. Many people around the country would be surprised to find out that prohibition never actually left many parts of Texas, and until recently, several were within north Texas's metropolitan areas. For this reason, it seemed ingrained in the culture that an adult beverage was something earned and deserved, worth a trip and worth paying for quality. There were very few proper cocktail bars, though. In fact, the word "cocktail" was used liberally to describe any alcoholic beverage. I was introduced to several bartenders who were leading the charge to a better drink, guest by guest. They brought me into the fray, always treating me with respect and dignity. All of these wonderful bartenders are featured within the pages of this book and have since become my closest friends. These bartenders were not ignorant to what was happening in other major cities around the country.

The trick was to bridge the gap between the high end of the craft cocktail movement and the tastes of the general public in Texas. They did

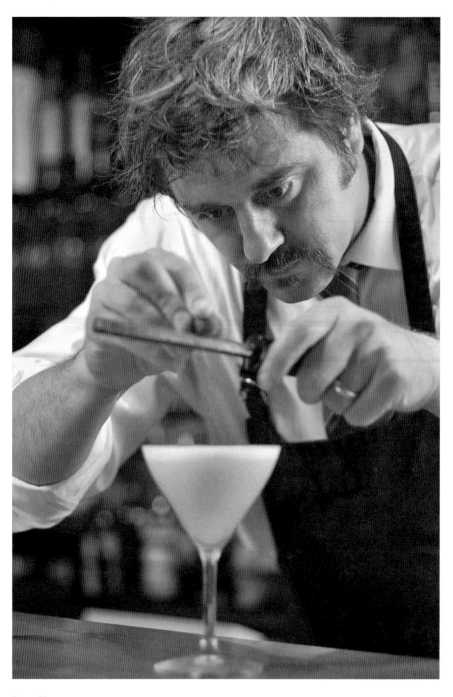

Jason Kosmas.

so effortlessly, bringing accessibility to the craft with elegance and charm. These lessons gave me a bigger sense of what a cocktail is and what it means to people. It is not just some high art, but rather something that is enjoyed between friends and family. My latest venture, The 86 Co., developed vodka, gin, tequila and rum for the craft bartender. Many of the decisions of how the product would reach out to the trade were influenced and counterbalanced by my early experiences in Dallas. To pay honor to that insight, we were happy to make Dallas/Fort Worth our initial launch market in 2012.

Having conducted a lot of historical cocktail research for my own book, *Speakeasy*, I was enthralled at how the culture of prohibition shaped the way we drink in America and how it has evolved over time. Never in my exploration did I come across popular references to Texas, so I was delighted to meet with Rita in her early days of writing *Prohibition in Dallas and Fort Worth: Blind Tigers, Bootleggers and Bathtub Gin*. Often described as "Where the West Begins," Fort Worth and Dallas both grew to be major metropolises during the Prohibition era. Enjoy the stories and recipes of great bartenders past and present from the proudest state in the Union.

—Jason Kosmas

ACKNOWLEDGEMENTS

There are actually many people to thank for helping this book become a reality, particularly all the wonderful bartenders I met here in the Dallas/Fort Worth area and my coauthor, Jeffrey. Another big thanks goes to Russell Dandridge—you always put up with my working twenty-four/seven. Also, thanks to my three other best friends, without whom my life would not be complete: Anthony Mastracchio, Tony Alunni and Kay Wiggs. Thanks as well to Michael, Julie, Rylie and Mike M. for being there when I need you. Finally, thanks to WW, BR and the golden-eyed Ariel.

–Rita Cook

YARBROUGH'S BEE'S KNEES

2 oz. Yarbrough Triplets Gin
¾ oz. Tara Honey Syrup
¾ oz. Granny Henderson Lemon juice
garnish with a Mom's Lemon Twist

Combine Yarbrough Triplets Gin (made with love from Jackson, Garrett and Mason) with the sweetest honey I know, Tara (my wonderful wife), and lemon juice by Granny Henderson (who allowed my granddad, Tige Henderson, to run beer joints after prohibition ended). Shake the ingredients with ice and add to a chilled bigInk coupe glass (made by Mallory, Brian, Kelly and the bigInk interns). Garnish the drink with a Mom's Lemon Twist, adding my mother's go-getter attitude that led me to become the entrepreneur I am today. Serves 1.

Special thanks to the Texas Restaurant Association for being an indispensable resource to our industry here in Texas. Also, thanks go to our research assistant, Valerie Exnicios, and to Dicki Lavine. And finally, thanks to God for giving me the passion and strength to work on so many great things at the same time in this industry. Cheers!

—Jeffrey Yarbrough

PROHIBITION IN DALLAS/ FORT WORTH

Prohibition was coming, and a headline in the paper in Dallas on August 1, 1917, said as much, noting "Senate Passes Pro Measure." The article reported that a "resolution to the states of a prohibition amendment to the federal constitution was adopted late today by the senate. The vote was 65 to 20, eight more than the necessary two-thirds. As adopted the resolution contains a provision that the states must be asked to ratify the amendment within six years. The house must act on the resolution."

In 1919, it was noted in Dallas that voters of that city and Dallas County approved prohibition and women's suffrage amendments to the state constitution, and at the same time, the papers reported that the Dallas chapter of the National Association for the Advancement of Colored People (NAACP) persuaded the city to cancel a presentation of a stage version of *Birth of a Nation*, while the city also raised $7 million for the Liberty Loan Drive to help pay the nation's debt for World War I.

When it was first decided that this book would be written, the idea was to find the best of the best bartenders (or mixologists) in the Dallas/Fort Worth area and let them speak about the big-time cool factor that has become the speakeasy culture of many bars these days. Besides, even today in parts of the Dallas/Fort Worth area, you can't buy alcohol, so while prohibition is no longer alive and well, you wouldn't know it looking just anywhere around here.

So, with that, I started asking around. Sure, I drink a good cocktail or two on a regular basis. And sure, coauthor Jeffrey Yarbrough had a list of

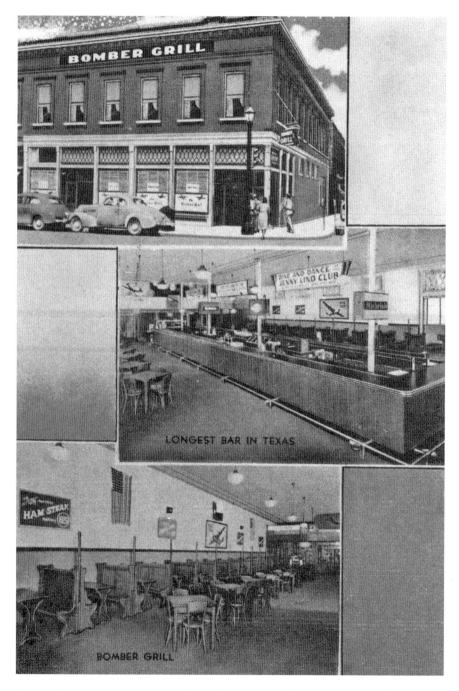

Bomber Grill and the longest bar in Texas. *Thomas Kellam, Tarrant County College, Special Collections.*

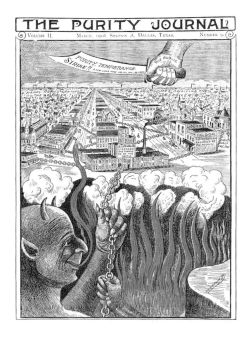

Cover of the 1906 *March Purity Journal*, from "Fort Worth, a Modern Sodom." *Dallas Historical Society.*

bartenders who were "must go to see" guys. But when all was said and done, and after I had scribbled down the names of the mixers and made my list (checking it twice), these names rose to the surface and kept coming up; they have become the root of this book about cocktails in Dallas/Fort Worth.

Another good thing was that these five men and one woman, and the bars they own and tend, aren't likely to go anywhere fast. So, with no further ado, while the history is fun in regard to the Prohibition era in Dallas/Fort Worth, what is more fun is talking with (in no particular order other than alphabetical) Curtis Cheney, Brad Hensarling, Jason Kosmas, Tyler Lott, Michael Martensen and Charlie Papaceno.

So let's take a look at prohibition through the eyes of these bartenders extraordinaire and dive right in from there. As Jason Kosmas said to me during our interview, "Sometimes it is fun to pass along the legends and the mythology of the cocktails because that is what makes it so powerful, and I think when you debunk it, that takes away the magic."

First of all, most drinkers these days (even if you only drink a little) take for granted the fact that it is not against the law to sidle up to a bar and order a drink. However, up until 1933, you couldn't legally get a decent drink in the United States thanks to the Eighteenth Amendment, ratified on January 16, 1919:

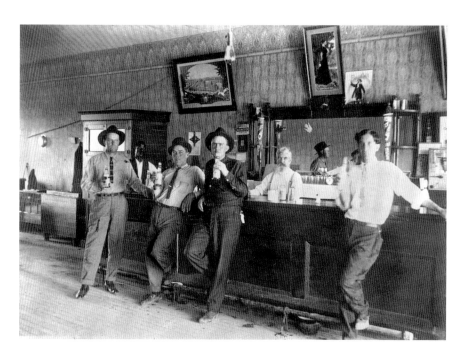

SECTION 1. After one year from the ratification of this article the manufacture, sale, or transportation of intoxicating liquors within, the importation thereof into, or the exportation thereof from the United States and all territory subject to the jurisdiction thereof for beverage purposes is hereby prohibited.

SECTION 2. The Congress and the several states shall have concurrent power to enforce this article by appropriate legislation.

SECTION 3. This article shall by be inoperative unless is shall have been ratified as an amendment to the Constitution by the legislatures of the several States, as provided in the Constitution, within seven years from the date of submission hereof to the States by the Congress.

With the amendment repealed on December 5, 1933, the government finally made it legal to drink in the United States again:

SECTION 1. The eighteenth article of amendment to the Constitution of the United States is hereby repealed.

SECTION 2. The transportation or importation into any State, Territory, or possession of the United States for delivery or use there in of intoxicating liquors, in violation of the laws thereof, is hereby prohibited.

SECTION 3. This article shall be inoperative unless it shall have been ratified as an amendment to the Constitution by conventions in the several States, as provided in the Constitution, within seven years from the date of submission hereof to the States by the Congress.

Indeed, while you might not have been able to get a good drink legally between 1919 and 1933 in the United States, you could definitely get a good drink illegally, and that's where the word "speakeasy" (a place for the illegal sale and consumption of alcoholic drinks, as during prohibition in the United States) actually comes from, as well the terms "bathtub gin" (homemade gin) and "blind tigers" (places where alcoholic beverages were sold illegally, also known as speakeasies and sometimes "blind pigs").

Keep in mind, too, that most of the savvy and cool bartenders of the Prohibition era packed their bags when prohibition became effective and

Opposite, top: Interior of Herman Schertz's Saloon at Elm Street (now 2723 Elm Street, Daddy Jacks Bar). The man at the bar in front is Herman P. Scherz, 1900. *Dallas Public Library.*

Opposite, bottom: Men drinking in a saloon. *North Fort Worth Historical Society.*

headed across the pond or even to Havana, Cuba, where Americans could still go to drink. They found some great cocktail creations too.

It's true that when we think of prohibition today, we most often think of flappers, gangsters with hats, well-known authors like F. Scott Fitzgerald and Ernest Hemingway and the good old jazz age, but where exactly did Dallas and Fort Worth sit in regard to what was happening during this time?

Since alcohol was believed to be the cause of all the problems in the United States (crime, poverty and more), some folks felt that it only stood to reason that without alcohol, all these social problems would go away. Not so much, really, and we can thank President Franklin D. Roosevelt, who was elected in 1933, for overturning the big "no drinking" law in this country and setting life straight again.

WHAT ABOUT MOONSHINING?

Everyone has heard the word "moonshine," and most folks know what it means (the unlicensed distillation of whiskey), but in Texas, moonshining dates back to when it was called "white lightning," and it was first introduced by the early folks who came to the state before prohibition. However, it was during the Prohibition era that the market for this illegal whiskey became popular.

Another fact about prohibition in Texas is that there were counties and communities in the state that had already prohibited liquor by local option laws in 1876 and 1891; these laws were successful in closing a good many of the legal saloons in Texas even before the end of World War I. However, with the closing of the saloons, it meant that moonshine got a boost, and this boost actually found its strongest legs during the period of national prohibition from 1919 to 1933.

Moonshiners in Texas were even said to have reached a sort of "folk hero" status during the time. When the economy was bad, folks turned to moonshining to make money. As such, it is said that during the Great Depression, there were people who felt that moonshining was a good alternative to no money or food on the table. Regarding the law, it is known that many elected officials kept a "don't ask, don't tell" policy because many otherwise well-respected citizens had to turn to moonshining as a means of money.

A recipe for moonshine at the time might include corn whiskey with about fifty pounds of sugar and the same amount of steel-cut corn chops. Then

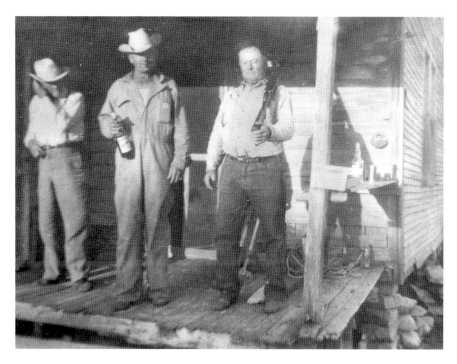

Family photo during Texas prohibition. *Jeffrey Yarbrough.*

you would add thirty-five gallons of water and let it sit for seven days. When it stopped bubbling and turned a blue color, then it was distilled and was good for five or six runs—sometime with a bit of sugar, water and grain added for more. Even so, the mixture already made about sixty gallons.

It has also been discovered that Dr. Pepper was also a good ingredient to add to the mix to get the process going faster. The moonshine could be cooked off faster, too. Most people have also heard that moonshine could kill you; this was due to the fact that to speed up the process, the ingredients might be put through an automobile radiator with battery acid added. While it cooked well, the lead from the old radiators could mean lead poisoning, paralysis, brain damage and sometimes even death.

Near the end of prohibition, it was also noted that attitudes changed from the beginning regarding women and drinking. This was one of the most noteworthy changes of that time. Before then, drinking was a man's game, but not so after prohibition and the world of the speakeasy.

THE SPEAKEASY

The speakeasy actually got its name because a person had to whisper a code word or name through a small slot in a locked door in order to get inside. Basically described as "underground bars" that quietly served liquor and sometimes food, speakeasies were unmarked places, and raids were not uncommon. To that end, owners would bribe police officers to let them go unnoticed, and many speakeasies were funded by organized crime in the area, although not particularly in Dallas.

Overall, prohibition was not popular in America and certainly not in Texas. Drinking during this time meant that some of the mixed cocktails of the day (before and after prohibition) used fresh fruit to counteract the bad taste of the liquor that was being used.

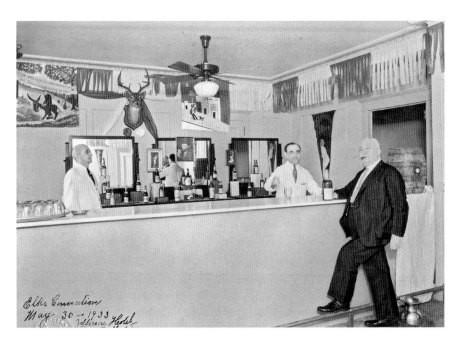

Jefferson Hotel bar, stocked for an Elks convention. This image was taken several months before prohibition was repealed. The bartenders are Maz Hirsch and Sid Moose. *Charles Mangold, Dallas Public Library.*

A LOOK AT PROHIBITION
IN DALLAS

In Dallas, the powers that be had no tolerance for bootlegging, drinking or just generally having a good time. That's what all those pesky teetotalers thought, anyway, and they didn't need to know anything different. It is reported that in the Dallas/Fort Worth area back in the day, there were many raids staged for show so folks would be encouraged not to drink, or at least the impression could be given that drinking was a "no-no."

That great Fort Worth establishment that is still around today, the White Elephant Saloon, was reportedly founded in 1884, and you can bet that they were drinking there during prohibition.

"Dripping Dry Dallas" was the nickname that the city was given after the repeal of prohibition in 1933, but banners and posters were everywhere in the city demanding that "The Saloon Must Go." Historian William S. Adair quoted a local resident saying, "Dallas was as quiet, law-abiding a community, as could be desired, until outsiders began to pour in in anticipation of the railroads, which were heading this way. Then, it began to fill up with saloons, gamblers and dance halls, wild men and wilder women."

Dallas historian and author Darwin Payne said of the Prohibition era in Dallas/Fort Worth that it was a really vibrant scene. While officers were raiding, pretending like they cared and holding an "evil bottle of spirits in their hands among barrels and stills as if to say 'don't do it,'" it was indeed a different story underground.

While officials in Dallas were acting like they were keeping the streets pure, one report of raids in 1929 almost exposed the whole scheme. A writer

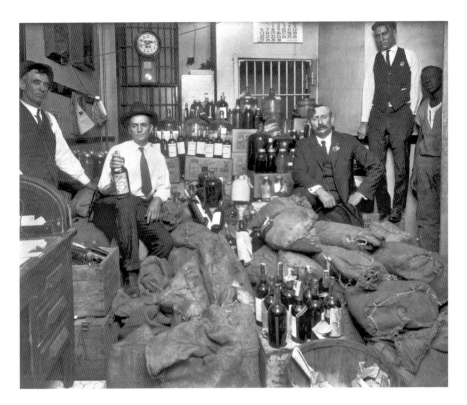

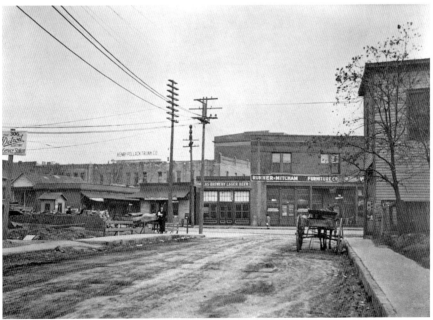

for *Collier's* magazine noted that officials were being paid by bootleggers to turn a blind eye to their bootlegging. After all, it was reported that said writer, Owen P. White, came to Dallas in 1929 to write a story about bootlegging and found six places to buy liquor in just a two-block area in Dallas's downtown area. He concluded that there were about one hundred or more sites in Dallas that were doing the same.

To make a point, the Dallas County sheriff at the time, Hal Hood, decided to conduct a series of raids to prove that officials weren't in bed with the likes of those awful bootleggers, and the raids resulted in about five thousand gallons of alcohol being confiscated and taken to a public rally in downtown Dallas staged by—who else?—the temperance movement folks. All was going well during the rally until the officials poured the liquor into the gutters and someone decided to light a match and throw it into the mix, resulting in a big fire. Firefighters were called, but by the time they arrived, as many as two dozen cars had burned, and the buildings nearby had become almost engulfed in flames.

The 1930s in Dallas saw those in charge taking a real look at the suggestion that perhaps prohibition wasn't working. Politicians were also beginning to get the idea that alcohol-related taxes for government during the early parts of the Great Depression might be a good idea. The end result was the repeal of the Eighteenth Amendment in 1933. However, as things are always bigger and better in Texas, the repeal happened twice in the state—first with the ratification of the Twenty-first Amendment in 1933 and then with the repeal of the Texas state amendment in 1935, as Texas voters had approved a separate state prohibition amendment in 1919.

There was no way that Dallas/Fort Worth was anywhere near dry anyway, even with the 1919 vote or the state amendment, and it is noted that the city was filled with bootleggers, speakeasies and dance halls during the 1920s and early 1930s. In fact, by 1926, bootleggers were reportedly making as much as $36,000 a year, not a bad salary if you can get it.

Opposite, top: Four law enforcement officers sit among confiscated stills and liquor. *Dallas Public Library.*

Opposite, bottom: Street scene looking toward Pacific Avenue. *Courtesy Dallas Brewery Lager Beer, 1915. Dallas Public Library.*

Let's talk about the Anti-Saloon League of Texas. It started out as a bad idea in 1902, and the league finally got enough momentum to be formed by 1907. A Baptist preacher named Benjamin Franklin Riley had the idea for the league and was the superintendent, putting the headquarters for the Anti-Saloon League of Texas right in the heart of Big D.

The main, national branch of the league had actually been formed in 1895, and the Texas league proudly modeled itself after the Ohio Anti-Saloon League, which had taken roots in 1893 to fight for laws prohibiting the manufacture, transportation and sale of all alcoholic beverages. In Ohio, that league was all about the single prohibition being nonpartisan and being applied to big business and bureaucracy that needed to be reformed. As the league's message spread, it trickled down to the South, where there were initial problems of forming the league because of the problems of segregation in the South. Even without the Anti-Saloon League of Texas, of course, there were other prohibition organizations marching to the drum of alcohol repeal, like the Woman's Christian Temperance Union.

The Texas Woman's Christian Temperance Union was organized by Frances Willard during a number of tours she did in the South from 1881 to 1883. She made her way to both Paris and Denison, Texas, near Dallas in May 1881, and around that time, she put together the state's first union in the city of Paris, Texas, at prohibitionist Ebenezer L. Dohoney's home. She came back the following year and continued to rally support, and the organization was formed in May 1982. However, it was Jenny Bland Beachamp who made the group take action. After she began traveling for the cause, membership numbers skyrocketed to about 1,500 by 1887.

With segregation in the South, there where white and black women chapters, and there were six black unions by 1886. Lucy Thurman became the head of the "Colored Division" in 1895 and formed a union in Dallas in 1897; all of this increased the visibility of temperance in some folks' mind, good for putting liquor dealers out of business and making national prohibition a reality.

As soon as the Texas Anti-Saloon League wormed its way into Texas and the Dallas area, the group became immediately involved in Texas prohibition and politics. It took credit for a good ten to eleven years before prohibition in the winning of local-option elections to ban liquor trading in twelve counties in the state. A man named Joel H. Gambell led the Texas league after 1910, and in 1915, the national office finally reorganized the Texas league. Gambrell was born in Tippah County, Mississippi, where he attended the University of

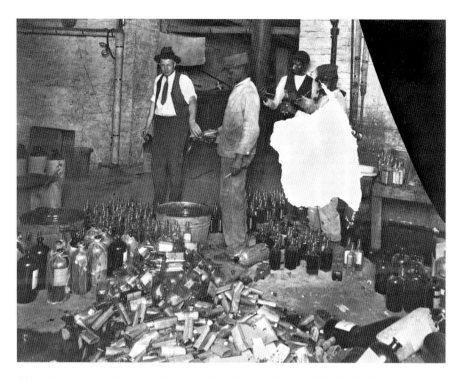

Alcoholic beverages during prohibition. *Frank Rogers Collection, Dallas Public Library.*

Mississippi from 1872 to 1876 and taught in the Mississippi school system until 1878, studying ancient languages at Mississippi College. He was a licensed Baptist minister and the Mississippi state prohibition organizer from 1881 to 1885. He was also a pastor in Mississippi and Georgia until moving to Texas in 1898. He was a pastor in Tyler, Texas, and later became editor of the *Baptist Standard* in Dallas. He was named the general missionary by the Baptist General Convention of Texas.

From there, the leadership (with new officers in place) was under the guidance of a man named Arthur James Barton, and he made sure that the Texas league was active and aggressive in raising money to further the cause of outlawing booze. At one point, the group even bought a paper called *Home and State* and made it *the* paper for folks to know and understand the league's local ideas and viewpoints. In 1916, the league met defeat when it wanted to institute a state prohibition; it won the majority of voters, but legislative folks said no. Even so, the league was still happy to take the credit for adding another dozen counties to the list of "dry."

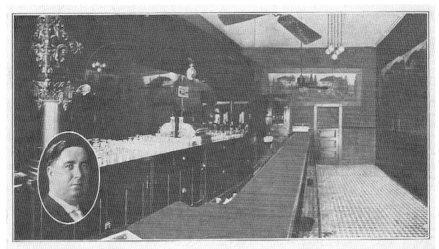

101 BAR, PAT HANNON, Prop. 323 N. Ervay St., Dallas, Texas

Old Saloon of Dallas. *Jim Wheat's Dallas County Texas Archives.*

After the prohibition forces won on a national level, all bets were off, and the Anti-Saloon League in Texas was happy but not needed anymore. It is noted that from a national standpoint, there were a lot of questions about the league's thoughts on enforcement of or education about prohibition. The new Texas superintendent of the league, Atticus Webb, thought that education the wiser choice. So, in 1927, the state embarked on a highly visual educational campaign regarding the prohibition movement.

It was really the Great Depression in the United States that had a big impact on prohibition overall, and while the national and Texas leagues were still doing their politicking in 1928 against a presidential candidate who liked the drink, Alfred Smith, the Depression was still a big deal in the United States at the time, no matter how you looked at it.

Taking a look at prohibition in Texas and how it influenced things in the state and in the Dallas/Fort Worth area, one only needs to look as far as those folks who thought that all forms of drinking alcohol were sinful and caused social damage. The temperance movement at this time was quite successful and continued alongside the prohibition movement, but in the eyes of many, temperance was just not enough—only outlawing the evil drink would do. They wanted to see an end to anything related to distilling, brewing and even saloons, as these were just ways to encourage and promote folks to drink.

Teetotalers felt strongly that drinking was immoral, so it stood to reason that state-enforced teetotalism would mean higher public morality. The nondrinking folks became known as "drys," and even way before prohibition, they were meddling in Texas state politics in regard to temperance. Basically, the drys wanted voters to do the right thing and declare their own form of prohibition in neighborhoods, towns, cities and counties. They also wanted to take that all the way to the statewide jurisdiction, asking for an amendment to the Texas Constitution declaring alcoholic beverages illegal. Even as early as 1843, the Republic of Texas had passed a law regarding alcohol consumption, and in 1845, a state law banned saloons, but this law was never enforced and was repealed in 1856.

Sometime around this era, the United Friends of Temperance, the first Texas-wide dry organization, was formed as a state branch of the Woman's Christian Temperance Union, formed in 1883. At the turn of the century, the idea of prohibition moved into the more rural counties in the north Texas area, including Dallas/Fort Worth. The liquor industry, of course, had lots of money to finance a campaign against temperance, but the publication *Home and State* also began doing its own thing, reporting on the merging in 1908 of the Texas Anti-Saloon League with other groups that preached against drinking.

One or Two Names to Know in Dallas at the Time

Benny Binion was a Dallas gambler and mob boss whose name is often associated with the Dallas prohibition scene, whether it is legend or fact. He has been described as a "soldier of fortune" at the turn of the century in Texas, and he was said to be not only a gambler but also a bootlegger, a man who left his mark in Dallas.

He was born in Grayson County, Texas, near Dallas, and his father was a horse trader. Binion's Federal Bureau of Investigation (FBI) file talks of his criminal history beginning in 1924 and includes a list of crimes like theft, carrying concealed weapons and even two murder convictions. He moved around a lot and ended up in El Paso as a teenager. That is where he began moonshining. In 1931, he got his first conviction for murdering a rumrunner whom he said had stolen liquor. An argument ensued, and the guy ended up

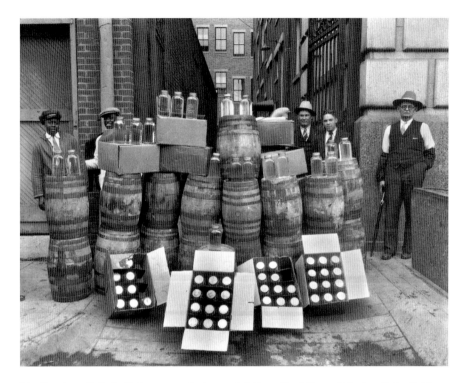

Confiscation of alcoholic beverages during prohibition. *Frank Rogers Collection, Dallas Public Library.*

dead. Binion fatally shot him through the neck, and that is how he was given his nickname, "the Cowboy."

By 1936, he was in control of the Dallas gambling world, and by the 1940s, he was called the "reigning mob boss" of Dallas, looking toward Fort Worth, where the local mob boss there eventually ended up dead too. Binion was known to have always carried three pistols: two .45 automatics and a small .38 revolver.

The Chicago folks eventually made their way to Dallas after World War II, and Binion moved on to Las Vegas, but he finally ended up in Leavenworth in 1953 for tax evasion. Still, his life had a big impact on the drinking scene in the Dallas area during prohibition.

Another name that Dallas folks often associate with prohibition is Jack Ruby, the owner of the Carousel Club in Dallas, which was across the street from the Hotel Adolphus at 1312½ Commerce Street, above a delicatessen. Outside the club, you could see photos of burlesque dancers for free, and inside, you could see it all for just two dollars.

Ruby did not get in trouble during the Prohibition era itself. From 1949 to 1963, he was arrested eight times by the Dallas Police Department, with fines of ten dollars for disturbing the peace and more for carrying a concealed weapon or violating state liquor laws, as well as charges of assault.

A Dallas Namesake with a Faint Memory of Prohibition

Al Martinez is the grandson of Faustina and Miguel Martinez, founders of Dallas's iconic El Fenix Restaurant, which was purchased by Mike Karns in 2008. Karns has opened even more El Fenix locations in Texas, but the name, regardless of the owner, will always be a Dallas landmark.

Regarding prohibition in the Big D, Al said that his father, Alfred, who is eighty-eight years old, has told him that for as long as he can remember, El Fenix offered beer and wine to the customers. When El Fenix Restaurant opened El Fenix Ballroom in 1938 next door to El Fenix Café, beer and wine were sold. For those who brought in hard liquor, the customer was charged a corkage fee. The fee entitled the customer to ice and mixers, such as Coke, 7 Up and ginger ale.

Al said that he had a 1936 *Dallas Amusement Guide*, which was published for visitors to Dallas during the Texas Centennial celebration. The guide lists and describes such establishments as the Century Room at the Adolphus Hotel; Chez Maurice in the Santa Fe Building; El Tivoli Night Club, located five miles from downtown on the Fort Worth Turnpike; and French Casino at Live Oak and Pearl, where it notes "[g]uests could enjoy good food and drink, floor shows, orchestras, dancing." Guests were encouraged to "dress to the nines."

"I suppose this is what is meant by the era of sophistication and glamour," Al said. "The El Fenix Ballroom featured the El Fenix Orchestra. Jamming with the EF Orchestra in the wee hours were the Dorsey Brothers; Harry James; Glenn Miller; [and] Benny Goodman, who would come to have beer and enchiladas at El Fenix when they finished their sets at the Empire Room and Century Room. El Fenix was open twenty-four hours a day in 1938, but World War II brought on a curfew, with the hours of operation changed to 6:00 a.m. to midnight and 1:00 a.m. on Friday and Saturday. The first night of the new curfew, my grandfather had no key to the front door, and

a locksmith was brought in to replace the old lock so that he could comply with the law."

Al added, "If I am not mistaken, mixed drinks were offered on the state fair grounds during the run of the fair that year, and restrictions were relaxed to the point that private clubs on the state fair's Street of Paris offered adult entertainment."

A LOOK AT PROHIBITION IN FORT WORTH

One place of mention in Fort Worth that was a tough place to drink was called Hell's Half Acre. This place offered just about the wildest kinds of establishments of any place in Dallas or Fort Worth. Hell's Half Acre was full of saloons, dance halls, gambling parlors and bordellos, and its big heyday was in the late 1800s, when cowboys frequented the area as they came through town on the ever popular Chisholm Trail.

Hell's Half Acre was located on the south end of downtown Fort Worth along Commerce and Calhoun Streets, and even in the early 1900s, it was still rowdy and remained so even after the Prohibition era. It was finally cleaned up in the 1960s when the city decided to make the location the home of the Tarrant County Convention Center.

The Fort Worth Police Department certainly had its hands full during the time of prohibition in Hell's Half Acre and beyond, and the task of enforcing the Nineteenth Amendment was added to the list of the department's responsibilities. It is noted that in conjunction with federal prohibition agents, Fort Worth police officers confiscated thousands of bottles of bootleg beer and liquor. In March 1927, sixteen thousand bottles of beer were seized and destroyed in one raid alone.

When reform was called for, mayors did their best. The likes of reform-minded mayor H.S. Broiles, as well as newspaper editor B.B. Paddock, declared war on Hell's Half Acre, but to no avail. Actually, the strongest complaints came from folks who wanted to get rid of the dance halls (where men and women frequented) and not so much the saloons and gambling parlors (most notably enjoyed only by men).

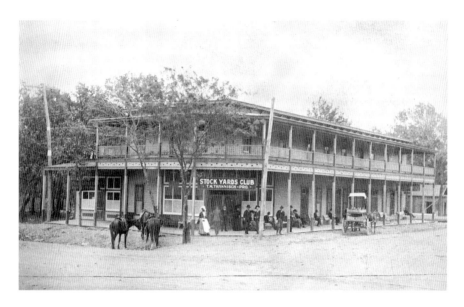

Stock Yards Club Saloon and Billiard Parlor. *Fort Worth Library.*

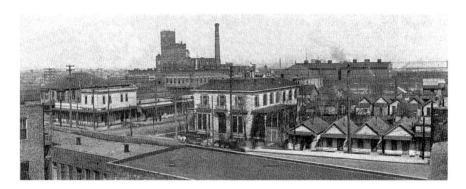

Bird's-eye view of Hell's Half Acre. *Dallas Historical Society.*

Other events put Hell's Half Acre on the map. By the time of prohibition, people knew that this was a "go to" place in Fort Worth. Not only was it notorious for gunfights, but also a prostitute named Sally was murdered and nailed to an outhouse door. With events like these going on, they added fire to the first prohibition campaign in Texas. A major reform campaign in the late 1880s and a prohibition campaign in Texas eventually had bought an end to the worst excesses of Hell's Half Acre by 1889. This meant that cheap gambling and prostitution were the norm, and in 1919, martial law was declared in Hell's Half Acre against

both prostitutes and barkeepers, with jail time and fines. Reform was on the move in Fort Worth.

A Brief History of Fort Worth

The story of Fort Worth is really a story of the taming of north Texas. It's a story highlighting the role that one city played in the early Texas frontier days, and without Fort Worth, well, where would the West have begun? After all, Fort Worth is, in no uncertain terms, where the West really did begin. That, we shall see, has been firmly rooted into the city's history.

All of the romantic notions come to mind when thinking of the early western cowboys; couple that with Indian fights and gunfights or, much later, cattle drives and rough-and-rowdy gangsters, and that's the real story. Later on, include those gushers that gave Texas oil its name and then, of course, the packing plants and railroads, assembly lines and today's ultramodern culture. It seems worlds away from those humble beginnings, but this is indeed the history of the city of Fort Worth.

Where the West Begins

Fort Worth is really the place to begin if you want to take a look at the American West. It's the seventeenth-largest city in the United States and the fifth-largest city in the state of Texas. Bordering Dallas County and located in Tarrant County, Fort Worth is on the very eastern edge of west Texas. In fact, "Where the West Begins" is the city's slogan and for good reason. Even with its size and its proximity to glittery Dallas, Fort Worth has not forgotten its roots. Those roots are easily identifiable not only in the city's western heritage but also in the lingering design and architecture that speaks of days gone by.

Established in 1849, the name "Fort Worth" holds a romantic ring, just like it did in earlier times, even if that romance belonged to a bunch of rough-and-tumble cowboys in a not-so-romantic time in our history. When Fort Worth was first established in the mid-1800s, it began as a desolate

outpost for the army, sitting on a bluff that overlooked the now popular Trinity River. Originally home to the Anadarko, Tonkawa and Waco Indian tribes, the land was fertile with game and water, and it was a good place to live, for both the Indians and settlers alike.

The Stockyards National Historic District has always been a big draw for tourists and locals for many different reasons. These days, there are a number of daily historic events, with the most notable being the twice-daily cattle drive along the city street in the stockyard area. It is the only one in the world of its kind. You've seen it in the movies, but in Fort Worth, you can see it live.

The history seen today in Fort Worth was a hard-earned history, and many stories relate to the earlier days on the frontier. It is where the West was won. From the cowboys and cattle drives that you can still envision on the streets to the railroad building and Hell's Half Acre, it's all about the stimulating beginnings of a city whose rugged pioneers left a legacy that still lives on today in the heart and soul of the city of Fort Worth.

Fort Worth's designation as the place where the West began was due especially to the city's association with the Chisolm Trail, a route used by the ranchers and cowhands to drive their cattle north. It wasn't long, then, before this route helped establish Fort Worth as a trading and cattle center in the Southwest. But so much more went into it, and it was the city's ability to build on its past that gave it the future both in the last century and today.

With the Chisolm Trail, it was proper that little Fort Worth would become known by its still popular nickname, "Cowtown." The cowboys stopping over in Fort Worth made sure that they had their fill before the long road ahead of them up north, driving the large herds of cattle out of Texas. From necessary supplies to enjoying the town's colorful saloons, gambling and carousing, the Cowtown reference was certainly a well-earned name for Fort Worth, and the locals now take pride in the designation, blending the cattle and the more recent oil heritage with a laid-back vibe you'll feel in the city today.

Fort Worth hit the ground running in the Roaring Twenties and didn't stop. From west Texas, more money just kept pouring in, with the vast amount of resources keeping Fort Worth on fire coming from industries like cotton, gin, oil and gas.

Amon Carter, a larger-than-life character from Fort Worth, was the publisher of the *Fort Worth Star Telegram* and still remains a big part of Fort Worth history throughout the 1900s but particularly during the Roaring Twenties. Not a caricature, Carter was definitely what folks think of when

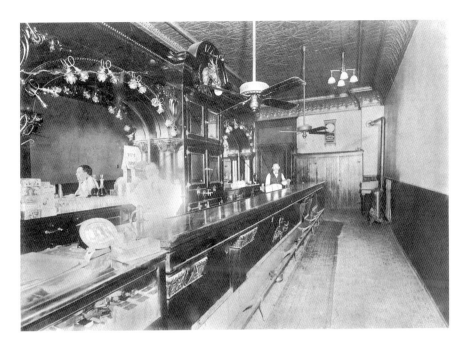

Forth Worth's "Old Stagg Saloon," which was at the corner of Sixth and Main. *Fort Worth Library.*

Westland Cigar Manufacturing Company, Hell's Half Acre. *Fort Worth Library.*

they think of a real "Texan." It is noted that he always wore a Stetson hat, with a bandana around his neck held in place by a diamond stickpin. He stuffed his well-tailored pants into his purple and white cowboy boots (now the colors of TCU), and he sometimes even wore chaps, spurs and a holster holding two pearl-handled pistols. A charmer for sure, by the early 1920s, his newspaper was already one of the largest in the southern states. Carter made this decade of Fort Worth's history worth remembering in so many ways, making and keeping his connections usually at a club in Fort Worth or entertaining at Shady Oak Farms on Lake Worth.

It was also during this decade that the city was able to take a good look at its past and be proud of how far it had come. This resulted in 1923 with what was called a Diamond Jubilee, held in commemoration. It was a weeklong affair, with parades and pageantry the likes of which were never seen before in Fort Worth. It was billed as "the biggest the state had ever seen." There was also a film shown of Fort Worth in earlier times, as well as football games played, Indian war dances held and, of course, an opening ceremony created specifically to remind folks of the city's stockyard roots, with a chuck wagon leading the way.

The mayor also requested that during the pageantry, all of the folks of the city dress from the era from fifty to seventy-five years ago. Needless to say, residents loved it. With cowboys and pioneer costumes everywhere, each street in Fort Worth had a different theme and party, from jazz or orchestras to minstrels, snake charmers and fortunetellers. The big event for the Diamond Jubilee that year was definitely the history pageant, with actors re-creating the military post establishment, the county seat being named in Fort Worth, the coming of the railway and even the success of Camp Bowie.

Also during the 1920s, there was a boom of oil frauds who took money from innocent people, but even that scandal did little to prevent the oil drilling from continuing legitimately in the area. New buildings were also being added to the Fort Worth skyline, and the company Universal Mills came south during this decade, offering Fort Worth a chance to boast that it was the now the grain hub of the Southwest. Other businesses also moved south in the mid-1920s, with plants producing batteries, rubber products, bricks, boxes and even a variety of tools. Justin Boot Company moved to Fort Worth in 1925 and fit right in with the stockyard and "Cowtown" image.

In 1922, railroad workers went on strike, but even worse was a meatpackers' strike that eventually resulted in violence, as could most strikes. It was a dark part of the city's history, and men were beat up and killed for crossing the picket lines. A cultural city by nature, in 1936 the world-famous Fort

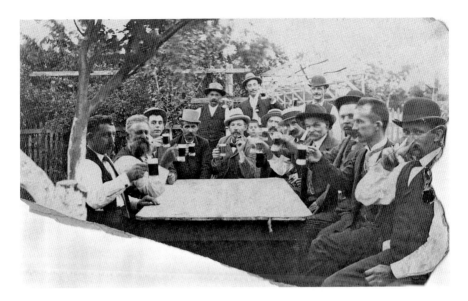

A group of men drinking beer at a table in Fort Worth. *Cathy Spitzenberger, University of Texas at Arlington Special Collections Library.*

Worth Casa Mañana was built, tagged as the "House of Tomorrow." It was *Star Telegram* owner Carter who fashioned the outdoor amphitheater and restaurant with a rotating stage and moat. Torn down due to the Second World War, Casa Mañana made its comeback in 1958. It was also rebuilt and remodeled again in the early 2000s. It is still standing today.

At the end of the 1920s, one thing did happen that affected the country. At first, though, it went almost unnoticed in Fort Worth, as it was only a dim problem in the city: the stock market crash of 1929. In fact, in the beginning, the paper reported the crash as a number-two story behind a more local robbery. A few days later, the crash wasn't even reported on the front page.

In the 1930s, the crash did eventually affect the city since unemployed workers were coming in by the multitudes, and the collapse in stock prices meant problems with economic ties in the other part of the country. With Fort Worth still in business—in fact, Fort Worth led the way in construction among cities in Texas in 1929 and 1930—people were pouring in for jobs and bringing fresh waves of transients in daily looking for work, especially in construction. The city opened its arms and did its best to take care of and feed the influx of people.

Also during this time, there were no shortages of bank robberies. One robbery in Fort Worth that was especially memorable was a heist that had

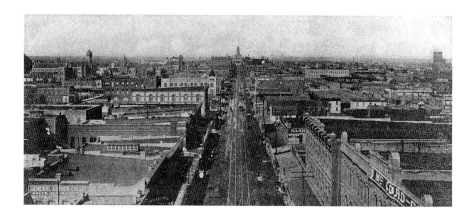

Main Street, Fort Worth, looking north from T&P Depot. *Dallas Historical Society.*

to do with a United States mail truck. While the heist ended up being a double-crossing in the end, and a murder resulted, it brought to light the likes of O.D. Stevens, the head of a crime operation in the city and in the Southwest. Narcotics and bootlegging were on his list of crimes, but in 1933, he and some of his associates held up a mailroom at the railway station. With $72,000, he headed to New York to launder the money out of state. When he returned to Fort Worth, several of his associates met with him and demanded their share of the money, but both men were killed at point-blank range. With a few of Stevens's other associates helping, they got rid of the bodies the good old-fashioned way: with concrete, dumping the bodies into the Trinity River. The dead men's wives, however, began to look for their husbands, and a young boy actually saw the bundle of concrete and dead flesh floating on the Trinity River surface before sinking. He reported it accordingly. Following a trial, Stevens was sentenced to the electric chair along with one of his associates, and the others involved were sentenced to many years in prison. Stevens somehow managed to escape the electric chair after a reversal and ended up only spending sixteen years in prison.

Other outlaws who came through Fort Worth in the 1930s included George "Machine Gun" Kelly; in fact, he even lived at his mother-in-law's house for a time in the city. Bonnie Parker and Clyde Barrow enjoyed time in Fort Worth, too.

In 1933, prohibition ended, and it didn't take Fort Worth long to learn to enjoy a drink. The then assistant city manager opened the first legal beer that day, and by the end of the day, Fort Worth citizens had drank

roughly thirty thousand cases and 12,800 drinks from the tap to celebrate the end of prohibition.

Arlington Steak House and Top O'Hill Terrace

A little place in Arlington, Texas, neighboring Fort Worth, is called the Arlington Steak House, and it is said that the second floor of the restaurant was a small speakeasy and gambling joint back in the day. It's on Division Street just north of the railroad tracks, and before it was known by its moniker today, it was called Triangle Inn.

Top O'Hill Terrace was considered a prime gaming center long before Las Vegas and has been defined as "the most luxurious gambling establishment in the United States." It was located in Tarrant County, but outside any city limits, and the first building at this location was built on the property by Beulah Marshall in the early 1920s—it was a fine dining establishment with dinner and afternoon tea in a tea garden that boasted view from a one-thousand-foot-high vantage.

In 1926, during prohibition, a Fort Worth man named Fred Browning bought the property and began what some defined as "unusual renovations." He moved the tearoom structure from its foundations and made room for a basement that was about two times the size of the tearoom in order to create an underground gambling casino. To get there, folks had to turn off a highway and drive down a nine-hundred-foot driveway to a parking lot behind the building. There was also a brothel that was reportedly on-site as well.

The grounds of the estate were wired with an alarm system, and there were always two guards standing at the ready at the gate, as well as a watchman to open the gate. Patrons entered through the back door as that was the main entrance, but there were said to be five doors that one had to go through before getting to the casino. The first door had a two-way mirror leading into an entrance hall, and then a person would pass through another door with a peephole and a hatcheck girl. The sign here read, "Park your revolvers here." The next door led into the lounge and restaurant area, and the third door had a small trapdoor, after which you were finally inside.

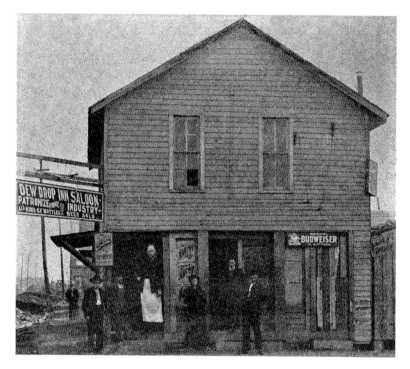

Dew Drop Inn. *Dallas Historical Society.*

In 1933, a man named Jack Poe began working at Top O'Hill at the age of thirteen; he first worked in the horse stables and then moved to the casino later. Rumor has it that he even met Bonnie and Clyde when they visited Top O'Hill, but the two were not allowed to bring in their guns.

In the underground casino, there was also a hidden room where it was said the gambling equipment was hidden during raids. Patrons could use the tunnel to come out topside in the tea garden. The tunnel was fifty feet long, four feet wide and ten feet tall, and it led to the west side of the wooded hill, which was mostly covered up with shrubbery. It was not until 1947 when Texas Ranger captain M.T. Gonzuallas led a raid that the casino was found out. What's more, Benny Binion was also a partner in Top O'Hill Terrace, which gave him the money to eventually build Horseshoe Casino in Las Vegas, Nevada.

Famous visitors to Top O'Hill Terrace included Bonnie and Clyde, Howard Hughes, Mae West, Jack Ruby, Clark Gable, Marlene Dietrich, Gene Autry, Lana Turner, John Wayne and Ginger Rogers.

Del Frisco's Curtis Cheney Talks Fort Worth

While he is not from Fort Worth, Texas, as the head of the bar at Del Frisco's Double Eagle Steak House in Fort Worth—as well as head beverage development for Del Frisco's Restaurant Group, which operates Del Frisco's Double Eagle Steak House and Sullivan's Steakhouse—Curtis Cheney has done his fair share of learning about Hell's Half Acre and the days of prohibition in Fort Worth. Here is what Cheney has to say.

From what I have gathered over the years, Hell's Half Acre was where a lot of the genesis of American western folklore really occurred. Writers and dime novelists were inspired by what was going on in Fort Worth, and it was the dancing girls and the piano players and, really, that Hollywoodesque vision that we have of the West, which is what Hell's Half Acre was all about. There were small towns, but there was not a saloon operating like that all the time. So, in a larger city like Fort Worth, you found it.

The building that is Del Frisco's was a brothel for many years, and I have tried to pinpoint how long it was a brothel, but from the best I can understand, the whorehouses weren't that well documented because they were, well, whorehouses. So, I think you have the social geographers who have Dallas and Atlanta as the South and Fort Worth and Denver as capitals of the West.

When it comes to prohibition, and that was really something that came from the East Coast—actually the East Coast puritanical WASPs shoving down their social ideas among everyone else. So you had the Midwest and then the West, and in the West, you didn't have the enforcement of prohibition like you did on the East Coast. It was fairly nonexistent in the South, and where you did find it, you did have folks bootlegging.

I have heard that down in Alvarado, Texas, was a very hot spot for bootlegging during the Prohibition era just south of Fort Worth. There is a lot of history about that; you also have Dallas/Fort Worth, and you have that southern Christian thing, Southern Baptist thing in Dallas, and you really don't have that in Fort Worth. Dallas just got rid of their dry areas recently; they don't know what a dry area means in Fort Worth. Here a dry area means there is no oil.

What is interesting about prohibition in the DFW area is the two sides to the same brain—you have one side that says it is demonic and the devil's cut, and the other side that said we will just have a drink or two. In my experience, you get a lot more binge drinking and weird behavior from people when you are oppressive.

I am from Chicago and have been in Texas twenty years, but it always blew me away that there are dry areas where you couldn't buy alcohol. I worked in Dallas for fourteen years and here in Fort Worth for about four years, and the two cities might as well be one thousand miles apart.

I had a conversation with a guy who worked at Jack Ruby's Kit Kat Klub. He was a drummer, and I asked him about Mafia because in Chicago there really is the Mafia. I asked this guy what is up with the Mafia. He said Dallas is an open city and it always has been. There has not been the mob-run things; they may have been traveling through here and their shipments, but the Mafia didn't do that. The smugglers were smugglers that worked for the Mafia, not Mafia directly. So, from my understanding, Dallas was always an open city, and any kind of illusions like the Kit Kat Klub and Mafia—that is a lot more myth than actual reality. There was not that immigrant working-class wave that you saw in the cities that spurred Mafia. We did not have the Irish and the Poles and the Jews and the Italians—people just kind of showed up here, so I highly question when I hear there was a lot of bootlegging.

The speakeasy has also been glorified. I heard from an old-timer in Dallas in the mid-'90s. I asked him for his unicard with the whole dry area and everything, and I said it just seems so silly, but he said, "Let me explain to you how it works." He said, "What you used to be able to do was go and take a bottle of booze to your buddy's house or his bar, and then he would keep that liquor for you in a box or in a locker. And he would run a tab on how much booze you had. For a penny or two, he would provide the ice and the glass, so go to someone's bar on a Saturday night and have a few drinks of your own booze. And there may have been some type of transportation thing, so this way you are not traveling with it, and that might have been bootlegging. So you keep it as his house and pay him for a setup charge, and this was during prohibition." This makes complete sense and if you look at dry areas in Dallas where you had bars, and legally, a bar, the establishment, did not own the alcohol; the members did. And that is why you had to be a member to drink. They didn't charge you for the alcohol but for the setup charge, and they taxed you 14 percent, and that is the highest in the United States for the booze.

In north Dallas, where I worked in the Knox Henderson area, if you were in a precinct that was surrounded by three other dry precincts, it made you dry. And the irony is that toward the end, the areas were under attack, and the distribution system was such that suppliers have to sell to distributors and then they sell to liquor stores, who then sell to bars instead of bars

buying from distributors or bars buying from suppliers like you can every other product. The large Baptist and Christian element in north Texas has gotten together with the TPSA (Texas Packaged Sellers Association), and now it is their combined resources and marketing to make sure that these laws that are going to loosen the access to alcohol up are prevented. So now you literally have liquor stores and big churches in the same car together with the same agenda.

For example, too, this is where you see there are eight liquor stores in one area since they tried to zone them, but that is starting to change because of revenue. Alcohol produces revenue, and that is one of the most highly taxed consumer product out there, rivaling cigarettes. The federal tax that a distiller pays to the federal government is $2.14 for every 750 milliliter of 40 percent alcohol.

Here locally, I asked if someone wants to sit at the bar and have a drink before dinner, and they are like *no*, as if there is some type of stigma there. And someone will say, "I am just having a seat," and I am like, I am not selling heroin or a lifelong addiction of poverty to you—it is just a libation. There is definitely a social stigma that lingers to this day.

Tiny's Tavern on Division Street in the 1930s, Tarrant County, Texas. *Linda Evans, Arlington Texas Public Library.*

Older people? I have met some people in Dallas, and I think what it does when you have these dry areas, it separates society and a bar. For most of our history in the United States, that was the place where the public ideas were debated and looked at as houses of ill repute or as places where people just get drunk. And that is where bad people went; then there was a lack of conversation.

At the dinner table, there are three things you are not supposed to talk about: sex, religion and politics. And I think those are the things that should be spoken about at the bar. If you are not engaging in those types of conversations, what kind of public dialogue do we get? We are hearing something from our news station of choice that we get to parrot back and forth, but we never actually hear any discussion or any type of dialogue where people can share their experiences, and when you drink a little alcohol, it loosens you up a little bit, so you might be open to discuss these things.

Also, bars in Dallas/Fort Worth are not social bastions. If I go to a bar in Baltimore or Chicago, Cleveland, New York, sitting there, having a drink, and I show up there for three hours every day for a week, within a week I am going to know people and I am going to make friends. Here I have seen people come into the same bar three or four times in a week for a long time, and nobody knows their name.

DRINKS FROM THE 1800S

WITH MIXOLOGIST AND
AUTHOR JASON KOSMAS

While prohibition did not become a reality until 1919, drinks that were popular during the Prohibition era were already being created as early as the 1800s. In fact, according to Jason Kosmas, author of *Speakeasy: Classic Cocktails Reimagined from New York's Employees Only Bar*, there was really only one drink invented during the era itself, and it was called the Last Word.

In an interview with the popular mixologist, Kosmas discussed his take on prohibition and how he and a few of his colleagues in New York City just might have singlehandedly been the ones to make Prohibition era drinks so popular these days. One thing that particularly stands out with Kosmas is his drinkmaking/mixing/bartending philosophy:

> *I think one of my favorite drinks that came out of that era was the Last Word: equal parts gin and Chartreuse and liquor and lime—and that leads me to believe that it took place more out of the country than in. It is credited with being created in Detroit, but it definitely became popular after prohibition, so it is a little bit shrouded in mystery like a lot of the cocktails are from that time.*
>
> *Some of the other good ones that I like are the Southside, which came out of the 21 Club before it was the 21 Club. Another one that is a big one for me too would be the New York Sour, with a history that no one knows, and that is basically rye whiskey, lemon juice and syrup and sometimes an egg white, and then you put a float of red wine on the top to add an incredible depth. It is one of the most amazing cocktails I have ever had.*

Jack Rose is a good one. It is applejack, mostly an applejack sour with grenadine, and that is actually the oldest distillery in the United States, one that has been in business the longest, and it is in New Jersey and ten minutes from where I grew up. My dad was a bartender in New Jersey, so they would use applejack for everything. That drink also has a story that is intertwined with corruption and police officers.

Some other ones I like are Pegu Club, and the Aviation is one that really made its name outside the country, and it is in the Savoy cocktail book too. I like strong women, so let's think about the Pink Lady, and there is a White Lady too—both are similar, and in terms of prohibition, one of the best innovations that happened during that time was that all the best bartenders left the country. Some went to Havana or Paris or London or Milan; they went to anywhere that Americans loved to drink, and what is cool about that is that they started to incorporate local ingredients and a lot of these drinks evolved differently like in the Caribbean.

In regard to Kosmas's book, *Speakeasy*, he said:

They originally wanted to call it Speakeasy Cocktails, *and it is the cocktail book for Employees Only, the bar and restaurant that I opened in 2004 in New York City in the West Village, and it is busier now than it has ever been. It is a small space, under two thousand square feet, nothing in the restaurant world, and we created it to be like a speakeasy. And we were one of the first people to do it like that with a fake façade, and it looks like one of those nondescript West Village fortunetellers that you pass in New York City. And there is a sign that says, "Psychic," and we have never had a fortuneteller not show up and that is cool. There is a small vestibule and then red velvet curtains behind her, and when you push open the curtains, it is 1920s and '30s Art Deco bar and dimly lit. We also found bar jackets that were representative of the era, sort of modified chef jackets, and all of the cocktails that we do there are basically the foundation that we re-envisioned of the classics. We would take classic cocktails and reinterpret them and always with an attention on creating our own drinks as well.*

In determining these inventions, Kosmas described their genesis:

I worked at this place called Pravda, and I was the bar manager there. Three of my partners in that project [included] Dushan Zaric and I, who I wrote the book, and it began because we were into used books and there

were books that we found on Ebay and used book stores. And you could find cocktail books that were hundreds of years old for five or ten dollars back then when we first started looking, and we gathered this great collection and started looking at how cocktails evolved. We would look at one recipe from the 1800s and then look at it from 1914, and you could see how it changed. Even after prohibition, the drink was completely different, and then you look at it in the '50s and it was like, "What was this drink?" So we would make the drinks and figure out how they were supposed to behave, but really what we did was also learn about the drinks. Dale DeGroff, one of the pioneers who taught me how to bartend, was really the one who gave me not methodology, but a technique of making tasty, full-flavored cocktails. It is almost one of those things that when you taste drinks that are good, you know when you fall short with the recipe. So we would look at these old recipes, and we would taste them and test them out. And we liked the idea of the ingredients in there maybe, but the ingredients didn't really showcase, so we beefed it up here or change it there and sometimes switch it around or have a new ingredient that we would want to play with and incorporate into our repertoire, so that was kind of how it happened. Every recipe was based on whether it was going to taste good, and then was it our style.

For a while, we were still trying to get a sense of what that style was, too, but as we evolved and put more drinks on the menu, then it became clear. We had bartenders submitting drinks, too, and we were thinking this might not be right, so try this or that and beef it up or knock it down or balance it. In the end, it is all about the balance with the drink. One way I do it is when I conceptualize a drink, if I can't nose it, then usually it does not belong.

While Kosmas is not a local Dallasite, he did say that he has heard of Hell's Half Acre and believes that perhaps there was an active prohibition scene going on there (he also mentioned the White Elephant):

I know that Fort Worth pretty much grew up…think about the time of prohibition, look at the Art Deco buildings between the '20s and '40s when they were built. So you have to imagine that there was probably less regulation [here], and it was easier to get away with it, and probably being in the West, I would imagine people were not as concerned—it was probably balanced out a lot by the Bible Belt too.

When asked how Kosmas determined the drinks he mentioned in his book, he explained:

The reason we called it Speakeasy Cocktails *was we really wanted to make sure that these drinks could have come before or after, and the reason we called it that was because it is kind of a time that people, in their minds, romanticize the idea of the cocktail more than anything else. A cocktail in their hand represents something more than just a drink, so a lot of the speakeasies were serving bad beer and bad booze, and sometimes you had to mix stuff to make it where it would not taste bad. The speakeasy, on the other hand, was doing high-end drinks, and it represented the first cultural revolution where you had people in bars together and becoming a bit more cosmopolitan and being carefree together and that kind of thing.*

So, while drinking and good cocktails have been around awhile, I asked Kosmas why the "prohibition-style" drinks, as they are called, are so popular now, as well as whether he feels like he had a part in starting that craze in New York City:

We were part of movement's beginning. There is a great place in New York called Milk and Honey, and they closed and are relocating, but two of their oldest bartenders are taking over the original space and that was called Reservations Only—it is small and it's a speakeasy in the fact that there is no sign and you have to buzz to get in. The décor, however, is not representative of that time period, but it is dark and black, and they were kind of the first ones to put hyper-attention to cocktails and classic drinks, and then everybody from the West Coast—or, really, all over the world— have replicated that style almost the way that Tiki bars were replicated in the day. That bar opened a few years before we did, but it was us and them and another lounge that were the first pushing these style of drinks and then a few more that happened after us, and all are were in New York. And then San Francisco started around that time with that type of bar.

Kosmas added:

You can always look at the food world and see where the bar world is going to be in a few years, so in the '40s and '50s, as everyone was packing things into cans and making frozen dinners, the same thing happened behind the bar, and everything became processed. An example is that you had sweet and sour mix, which you never had before, or prepackaged mixes and syrups, and that changed over time and the actual flavorings.

When I say you have to have fresh ingredients for your drinks, I don't mean that you have to take fresh fruit and muddle it; you can utilize fresh fruit too. I am surprised sometimes when a place will take an old drink like with gin and lime juice or raspberry, and I have seen people muddle raspberries and I don't understand why not take those raspberries and cook them down and make a syrup. The one thing that was taken out of bars, and this is the great distinction between a classic cocktail bar and what we have had over the last fifty years, is that the bar really exists in two parts. Traditionally, very similar to a kitchen, so you would have preparation versus execution, and that is what the kitchen does is prep all the things that are going to happen, and when they open for service, everything is ready to execute. You can prep a cocktail the same way behind the bar, and a lot of that preparation was taken out over the last fifty years, and that is why you have all of that pre-bottled stuff so you could literally open your door and cut some fruit and call it a drink. That is my opinion of the biggest difference between the two.

JASON KOSMAS'S MUSTS FOR
EVERY GOOD BAR

- *proper tools*
- *access to fresh ingredients*
- *quality spirits*
- *proper training: a united effort where you remove the egos at the bar. Kosmas noted, "You have to have a sense of pride amongst the staff that work within their walls, so you don't have someone who just wants to promote their own cocktails."*

Kosmas continued, saying, "I think the biggest mistake that most cocktail bars make is that they make it about the bartender and their drinks, as in, 'It is all about what I like and I am going to give you a drink that I think is amazing as opposed to listening to what you like and trying to figure out what that is.'"

Kosmas added that "really, a person should be armed with this knowledge and good at their technique no matter what. You also might try to turn someone on to gin. Gin was the liquor in so many drinks, so when you are going back and doing this research on classic cocktails, then it is whiskey and gin and then brandy and rum, and for that reason a lot of bartenders gravitate toward that."

He did add that many bartenders are also going against that "martini phase" that happened in order to shun vodka. "When I worked at a martini bar, we could turn people on to new ingredients, and anything you called a martini was safe in people's mind. Like I could say 'pomegranate,' and people wouldn't even know a pomegranate, but because I called it that people wanted to try it…It is always important to have lemon or lime juice or fruit of any kind, but you had less access then."

And without further ado, let's take a look at some of the most popular drinks from the 1800s and how you can make them at home.

AMERICANO (1860s)

1 oz. Campari
1 oz. sweet vermouth
ice
soda

Build Campari and vermouth in a Collins glass. Top with ice and soda. Garnish with a flamed orange zest.

BEE'S KNEES (1874)

It's a spoonful of honey in this case, plus lemon and orange juice, which would have taken the edge off bathtub gin in this cocktail, right? Enter the Bee's Knees. The honey is this concoction was able to soften that awful bathtub gin. While no one is sure of the actual origin of this little ditty, it was a prohibition drink staple. A variety of recipes abound.

2 oz. gin
½ oz. honey
I tsp. fresh lemon
juice

Combine ingredients together in a mixing tin. Shake. Strain into a cocktail glass. Garnish with a lemon wheel.

TYLER LOTT'S RECIPE

2 oz. Citadelle Gin
¾ oz. honey
½ oz. lemon juice

Bijou (1890)

A mixed alcoholic drink using gin, vermouth and chartreuse, *bijou* means "jewel" in French, and this drink was said to have been invented by Harry Johnson. It gets its name from its color of three jewels—gin for diamonds, vermouth for rubies and chartreuse for emeralds. This recipe is also one of the oldest in Harry Johnson's 1900 *New and Improved Bartender Manual* dating to the 1890s.

1½ oz. London dry gin
¾ oz. sweet vermouth
¾ oz. Green Chartreuse
2 dashes orange bitters

Add all ingredients to a mixing glass. Stir. Strain into a cocktail glass. Garnish with a flamed orange zest.

Brandy Crusta (1852)

Invented in 1852 by Joseph Santina at the Jewel of the South in New Orleans, this drink was a precursor to the Sidecar and, then, the Margarita.

2 oz. cognac
1 tsp. Orange Curaçao
½ oz. lemon juice
1 dash Angostura bitters

Add all ingredients to a mixing tin. Shake. Strain into a snifter. Garnish with sugar and the peel of half a lemon.

Brandy Crusta.

CHAMPAGNE COCKTAIL (1861)

The Champagne Cocktail has been mentioned in books as early as 1861 and uses brandy and orange liqueurs.

¼ oz. simple syrup
2 dashes Angostura bitters
Champagne (top)

Combine all ingredients in a Champagne flute. Stir lightly.

CLOVER CLUB COCKTAIL (1880s)

The Clover Club Cocktail is a drink that predates prohibition and was named for the Philadelphia men's club of the same name that met in the Bellevue-Stratford hotel. Today, grenadine is used instead of raspberry syrup, but the older recipe definitely stands out.

2 oz. gin
juice of ½ lemon
¼ oz. raspberry syrup
1 egg white
1 tsp. sugar

Pour the ingredients into a cocktail shaker with ice cubes. Shake vigorously to mix the egg and sugar. Strain into a chilled cocktail glass.

DAIQUIRI (1898)

2 oz. Cruzan Light
½ oz. lime juice
½ oz. simple syrup

Add all ingredients to a mixing tin. Shake. Strain into a cocktail glass. Garnish with a lime wheel.

DESHLER (1800s)

This cocktail is old and rare, and its name comes from the famous lightweight pugilist David W. Deshler Jr. The recipe can be found in both *The Craft of the Cocktail* by Dale DeGroff and *The Essential Bartender's Guide* by Robert Hess, with the Hess cocktail recipe being possibly the first of the two mixed.

2 oz. rye whiskey 2 dashes Peychaud's bitters
1 oz. Dubonnet Rouge 1 lemon twist
¼ oz. Cointreau

Stir and strain into a martini glass. Garnish with an orange twist.

GIMLIT (1867)

There are a few ways to make a classic Gimlet, and today you might prefer it with vodka and a fresh lime versus gin, but the old-time classic is indeed gin and Rose's preserved lime juice, so that's how we suggest you make it.

2 oz. gin
1 oz. Rose's lime juice
½ oz. simple syrup

Combine all ingredients in a mixing tin. Shake. Strain into a cocktail glass and garnish with a lime wheel.

MANHATTAN (1874)

This famous drink originated in the late nineteenth century. David A. Embury, who wrote *The Fine Art of Mixing Drinks*, mentioned it as one the six basic drinks in his book, and it is made with whiskey, bitters and sweet vermouth. Said to have been created for Lady Randolph Churchill, Winston Churchill's mother, at the Manhattan Club, the truth is that the drink was one of the five New York borough cocktails. The drink is served in a lowball glass on the rocks.

CHARLIE PAPACENO'S FAMOUS MANHATTAN AT THE WINDMILL LOUNGE IN DALLAS

2 oz. rye whiskey
1 oz. sweet vermouth
2 dashes Angostura
bitters

Stir with ice and strain into a chilled cocktail glass. Garnish with maraschino cherry. (Try making your own maraschino cherries. It's easy and much tastier. Get a package of frozen pitted cherries, place them in a jar and fill with Luxardo maraschino liqueur. Wait two days and voila!)

MARTINEZ (1860s)

TYLER LOTT'S RECIPE

1½ oz. Hendrick's Gin
¾ oz. Lucesta Reserva sweet
vermouth
½ oz. Luxardo maraschino
liqueur
2 dashes orange bitters

CURTIS CHENEY'S RECIPE

1 oz. gin
2 oz. sweet vermouth
dash Angostura bitters
dash maraschino liqueur

*Combine all ingredients into mixing
glass, add ice and stir for twenty
revolutions. Pour into martini glass
and garnish with lemon peel.*

MARTINI (1880s)

2 oz. London dry gin
1 oz. dry vermouth
1 dash orange bitters

*Combine all ingredients in a mixing glass. Stir. Strain into a cocktail glass.
Garnish with a lemon zest.*

MINT JULEP (1803)

While it is very likely even older than the early 1800s, the Mint Julep first appeared in a recipe book in 1803 and is traditionally made with mint leaf, bourbon, sugar and water. Somewhat associated with the Brandy Smash in some circles, it is expected that the ingredients be muddled for maximum flavor.

15 to 25 mint leaves 2 oz. Buffalo Trace bourbon
¼ oz. simple syrup 2 dashes Angostura bitters

Add mint to an Old-Fashioned glass. Muddle. Add all other ingredients. Top with crushed ice. Stir. Garnish with a mint sprig.

MOJITO (1890S)

10 to 15 mint leaves
2 oz. Oronoco
1 oz. lime juice
sugar

Add mint leaves to a Collins glass. Muddle. Add rum, mint, lime juice and a bit of sugar. Stir. Top with soda. Garnish with a mint sprig and a lime wheel.

CURTIS CHENEY'S RECIPE

3 to 5 mint leaves
2 oz. Treaty Oak Texas Rum
¾ oz. simple syrup
¾ oz. lime juice

In the bottom of a Collins glass, press mint leaves gently with a muddle stick. Add rum, simple syrup and lime juice. Stir slightly. Add ice and top with soda water. Garnish with lime slice.

NEW YORK SOUR (1870s)

The New York Sour reportedly dates back to the late 1870s and was created in Chicago by a bartender who also said that he invented the Manhattan. The latter can't be confirmed, but apparently the New York Sour can be credited to this bartender. However, the name of this cocktail reportedly has changed several times since it was created. It was also known over the years as the Continental Sour and the Southern Whiskey Sour before becoming the New York Sour.

2 oz. whiskey, preferably rye
1 oz. lemon juice
¾ oz. simple syrup

Add whiskey, lemon juice and simple syrup to a cocktail shaker. Add ice. Shake. Strain into a Collins glass filled with crushed ice. Float red wine on top and garnish with a lemon wedge.

OLD-FASHIONED (1800s)

If you like whiskey, sugar and bitters, then this is the drink for you—along with adding a maraschino cherry and orange slice just like they did during prohibition. It is said that this name was first used for a bourbon whiskey cocktail at the Pendennis Club, better known as a gentlemen's club that was founded in 1881 in Louisville, Kentucky. The recipe was said to have been invented by a bartender at that club in honor of Colonel James E. Pepper, a prominent bourbon distiller, who brought it to the Waldorf-Astoria Hotel bar in New York City.

The common garnishes for an Old-Fashioned include an orange slice or a maraschino cherry, but keep in mind that these modifications did not come around until 1930, after the original recipe was invented.

¼ oz. simple syrup
2 oz. Buffalo Trace
3 dashes Angostura bitters
3 dashes orange bitters

Combine all ingredients in an Old-Fashioned glass. Add ice. Stir. Garnish with a flamed orange zest or a maraschino cherry.

CURTIS CHENEY'S RECIPE

2 maraschino cherries
2 orange slices (half circles, at least ¼-inch thick)
2 dashes Angostura bitters
¾ oz. simple syrup
2 oz. bourbon

Muddle cherries, orange slices, bitters and simple syrup in an Old-Fashioned glass. Add bourbon and stir slightly to blend. Add ice and stir again.

PIMMS CUP (1823)

1½ oz. Pimms
½ oz. lemon juice
¼ oz. simple syrup

Add ingredients to a Pilsner glass. Add ice. Top up with bitter lemon. Garnish with sliced fresh fruit and mint.

CURTIS CHENEY'S RECIPE

2 oz. Pimms
¼ oz. lemon juice

Combine ingredients into shaker tin and fill with ice. Shake ingredients and pour into ice-filled Collins glass. Top with ginger ale and garnish with a cucumber slice.

RAMOS GIN FIZZ (1888)

When making the proper Ramos Gin Fizz, the egg white and cream are of utmost importance. The flavor is citrusy, using lemon, lime and drops of orange flower water with gin. Created by Henry C. Ramos in his New Orleans bar, other names include the New Orleans Fizz. The drink was a staple before prohibition.

2 oz. gin
¾ oz. lemon juice
¾ oz. lime Juice
1 oz. simple syrup
1 bar spoon vanilla extract
1 bar spoon orange blossom water
1 oz. heavy cream
1 egg white
1 oz. soda water

Combine all ingredients except for soda. Dry shake. Add ice. Shake. Strain into a sling glass. Add soda. Garnish with a flag.

RICKEY (1833)

Colonel Joe Rickey has been given credit for this drink's invention after a bartender at Shoomaker's in Washington, D.C., added a lime to his regular bourbon with ice and sparkling mineral water.

½ lime
¾ oz. simple syrup
1½ oz. base spirit

Muddle lime in an Old-Fashioned glass. Add simple syrup and spirit. Add ice. Stir. Top with splash of soda. Garnish with a lime wheel.

ROB ROY (1894)

This drink is said to have been invented by a bartender at the Waldorf-Astoria Hotel in New York City in honor of an operetta of the same name based on Scottish folk hero Rob Roy. Made only by using Scotch whiskey, the drink is similar to the Manhattan, which uses rye or Canadian whisky.

2 oz. slightly smoky scotch whiskey
1 oz. sweet vermouth
1 dash Angostura bitters

Add all ingredients to a mixing glass. Add ice. Stir. Strain into a cocktail glass. Garnish with a cherry.

SAZERAC (1838)

According to www.sazerac.com, it was in 1838 that Antoine Amedie Peychaud, owner of a New Orleans apothecary, treated his friends to brandy toddies of his own recipe, including his Peychaud's bitters, made from a secret family recipe. The toddies were made using a double-ended egg cup as a measuring cup or jigger, then known as a "coquetier" (pronounced "ko-k-tay"), from which the word "cocktail" was derived. By 1850, the Sazerac Cocktail, made with Sazerac French brandy and Peychaud's bitters, was immensely popular. It became the first "branded" cocktail. In 1873, the recipe for the Sazerac Cocktail was altered to replace the French brandy with American rye whiskey, and a dash of absinthe was added. In 1933, the Sazerac Cocktail was bottled and marketed by the Sazerac Company of New Orleans. That same year, Herbsaint, a pastis, was made according to a French recipe. Herbsaint was named for the New Orleans term for wormwood, "herb sainte." In 1940, the official Sazerac Cocktail recipe was modified to use Herbsaint as the absinthe. Finally, in 2000, the official Sazerac Cocktail recipe was modified to use Sazerac Kentucky Straight Rye Whiskey.

SAZERAC ROYALE

1 oz. Rittenhouse
1 oz. Remy Martin VS
¼ oz. simple syrup
3 dashes Angostura bitters
3 dashes Peychaud's bitters

Chill an Old-Fashioned glass. Combine first five ingredients in a mixing glass. Stir. Rinse an Old-Fashioned glass with Herbsaint. Strain into glass. Garnish with a lemon twist.

TOM COLLINS (1869)

1½ oz. Beefeater
½ oz. lemon juice
½ oz. simple syrup

Build first three ingredients in a Collins glass. Add ice. Top with soda. Garnish with a lemon wheel.

CURTIS CHENEY'S RECIPE

2 oz. gin
¾ oz. fresh lemon juice
¾ oz. simple syrup

Add gin, lemon juice and simple syrup into shaker tin filled with ice. Shake for 5 to 7 seconds. Pour contents into ice-filled Collins glass, top with soda and garnish with a cherry.

WARD EIGHT (1898)

An early creation of Ward Eight made this drink especially popular during prohibition. It used rye whiskey, with the harsh taste masked by lemon juice, orange juice and grenadine.

1½ oz. rye whiskey ½ oz. lemon juice
½ oz. grenadine ½ oz. orange juice

Add all ingredients to a mixing glass. Shake. Strain into a cocktail glass. Garnish with a cherry.

WHISKEY SMASH (1887)

The Whiskey Smash has been around since the 1800s and was first mentioned in a book by Jerry Thomas about bartending in 1887. Basically, it's a little bit of whiskey sour and mint julep. Many folks use Maker's Mark these days for the best blend overall.

2 lemon wedges
1 sprig of mint
2 oz. bourbon
¾ oz. simple syrup
1 oz. water
1 dash Angostura bitters

Muddle lemon and mint in the bottom of a mixing glass. Add all other ingredients and ice. Shake. Strain into an Old-Fashioned glass. Top with ice. Garnish with a mint sprig and lemon wheel.

WHISKEY SOUR (1860S)

2 oz. whiskey
1 oz. lemon juice
½ to ¾ oz. simple syrup

Add all ingredients to a mixing tin. Shake. Strain into an Old-Fashioned glass. Top with ice. Garnish with a cherry.

WIDOW'S KISS (1895)

The Widow's Kiss dates back to about 1895, during the time when cocktails were coming into existence and bartenders were trying all sorts of new things. This cocktail neatly puts together both Chartreuse and Benedictine for just the right flavors.

1½ oz. Calvados
¾ oz. Green Chartreuse
¾ oz. Benedictine
2 dashes Angostura bitters

Add all ingredients to a mixing glass. Stir. Strain into a cocktail glass. Garnish with a cherry.

DRINKS FROM 1900 TO 1909

WITH DALLAS MIXOLOGIST TYLER LOTT

A Texas native, Tyler Lott has been a bartender for six years, but she points out that she has only been in the craft cocktail scene for a few years now. "I started in a pretty generic pool hall serving lots of beer and Long Islands," she laughs. "When I came to Dallas and began working at Asador, I was given the chance to really expand my viewpoint on cocktails, and I just completely ran with it. Sometimes I feel more like a chef than a bartender, and I love it—all this fresh produce at my hands each day."

Bartender/mixologist of the restaurant Asador in Dallas, Tyler Lott first told how she became interested in prohibition cocktails with a modern twist:

> *I have always been very interested in the Prohibition era, but I became interested in prohibition cocktails after drinking my first Sidecar a few years ago. It was like a beautiful marriage between balance and simplicity. I began taking these perfected cocktails and add a twist to make it partly my own. I love to use fresh herbs and seasonal fruit like the Rosemary Fig Sidecar. Roasting the figs really brings out its wonderful flavor, and it pairs so beautifully with fresh rosemary. When you serve these drinks, you get to tell a story of two eras—one of its creation during prohibition and one of how we enhanced it to fit into today's cocktail scene.*

TYLER LOTT'S MUSTS FOR
EVERY GOOD BAR

"I think that as long as your cocktail menu is creative and has a wide range of balanced and consistent cocktails, your menu will be successful. Having a list with freshly prepared cocktails that use quality products and spirits is the best way to go. I am a big believer in quality over quantity, which is why I'm not a fan of batched cocktails."

Tyler Lott.

Five of the most popular drinks from the prohibition time, according to her, include the martini, Manhattan, Old-Fashioned, Sidecar and Sazerac.

I think that bartenders are looking to prohibition cocktails because of the consumers becoming more informed and more distinguished in their drinking habits. They are no longer wanting grenadine and pineapple juice thrown into every drink; they are looking for a balanced and well-created cocktail. These cocktails showcase the wonderful spirit that is put into it rather than trying to mask it. I also think that it is stemming from the trends of the food world. Restaurants are more focused on fresh, local and all-natural products than they have ever been. People want to know what they are putting into their bodies, and they want it to be as natural as possible. That's why bars are more focused on fresh herbs, seasonal fruit and natural spirits. The bar is once again a place for entertainment where the bartender is the entertainer for the evening.

As for the impact that Lott believes prohibition had on the drinking scene overall in DFW and in the country, she said, "I think that prohibition gave us the chance to explore other types of spirits because America was

forced to make them in bathtubs and barns. It also made drinking feel like a celebration because when prohibition ended, it was like a 'grand opening' for drinking in America."

So, when she hears the terms "bathtub gin" and "speakeasies," what comes to mind for her? "Speakeasies bring such a mystery to the cocktail scene and allows you to feel as though you walked into a different era completely."

ALGONQUIN (1902)

Billed by some as a "great martini," it consists of rye whiskey, dry vermouth and pineapple juice. The drink was named after the Algonquin Hotel in New York City, which was built in 1902, but it was known as a "dry" hotel even before prohibition began.

<div align="center">

1½ oz. rye whiskey

¾ oz. dry vermouth

¾ oz. pineapple juice

Add all ingredients to a mixing tin. Shake. Strain into a cocktail glass.

</div>

BRONX COCKTAIL (1905)

Called the perfect martini by some, the Bronx Cocktail has a blend of orange juice and was actually named number three in the "World's 10 Most Famous Cocktails" contest in 1934. It has also been designated as an "Official Cocktail" by the International Bartender Association. Like the Manhattan, the Bronx is one of five cocktails named for New York City's five boroughs. According to historian Albert Stevens Crockett, the inventor of the Bronx Cocktail was Johnnie Solon, who was a pre-prohibition bartender at the Manhattan Hotel, but other stories say that the Bronx was invented in Philadelphia, and it was discovered in 1905, so that's the year where credit is due.

2 oz. gin
½ oz. dry vermouth
½ oz. sweet vermouth
1 oz. fresh orange juice

*Combine all ingredients in a mixing tin. Shake. Strain into a cocktail glass.
Garnish with orange zest.*

CORPSE REVIVER #2 (1900S)

¾ oz. Beefeater
¾ oz. Cointreau
¾ oz. Lillet Blanc
¾ oz. lemon juice
1 dash absinthe

*Combine all ingredients in a mixing tin. Shake. Strain into a cocktail glass. Garnish with a
maraschino cherry.*

GIBSON (1908)

A drink using gin and vermouth, the Gibson was also served on some
occasions with a pickled onion, but bartenders noted in early recipes that
under no circumstances should bitters ever be used in this drink—perhaps
an olive could be added though. Some sources also indicate that the martini
of today was actually the Gibson from earlier times, but these days, the
Gibson is only so named when it has been garnished with an onion.

2¼ oz. London dry gin
¾ oz. dry vermouth

Add ingredients to a mixing glass. Stir. Strain into a cocktail glass. Garnish with a pearl onion.

Corpse Reviver.

DRINKS FROM 1910 TO 1919

WITH BRAD HENSARLING

There is a little bit of a misnomer because prohibition is pretty much single-handedly responsible for wrecking the really unique American cocktail culture," said Brad Hensarling, owner of not only The Usual in Fort Worth but also the Gold Standard and the Chat Room Pub. "As far as we can tell, dating back to the 1850s, Americans were the first ones to really start mixing stuff together, and you have a few phases in time or trends leading up to prohibition. And then, in 1919, that all went away, and the few bartenders that really wanted to ply their trade legally went to Europe."

Hensarling continued:

> Then there was just, due to lack of quality ingredients or access to quality ingredients or just the need to cover up the taste of the terrible basically moonshine or bathtub gin that was going around and cheap tequila was being smuggled across the border and things like that, and that is when drinks became significantly sweeter if you could get it. The bartenders became more skilled because it went from a culture of craft to a culture where you had to have people that were willing to do something entirely illegal for a living and not really care about the quality and just get it over the bar to the people that really wanted to drink.

Hensarling said that this is why you saw a lot of bars popping up, and it was interesting in the sense that cocktail culture and the quality went away. "That is when you see before the bar was entirely a man's world, and

then women started getting involved and going out to bars, which was actually unheard of prior to that. And the bar became a little more egalitarian, not really dealing with gender, but in some instances dealing with race and sexuality since that was a part of that speakeasy culture."

Hensarling said, too, that even after prohibition was lifted, there were definitely cocktails that remained popular and have since made great comebacks. The Manhattan obviously came back, and the Mojito has come around since then, but it was not until about fifteen years ago when Dale DeGroff was charged with the task of making a bar with fresh-squeezed ingredients

Brad Hensarling.

called the Rainbow Room in New York that you see this renaissance of bar culture that did not previously exist. Now you have the same level of creativity on a scale that is coming back around, as well as the attention to detail. In Dallas/Fort Worth, Hensarling is definitely a part of that culture.

He noted, "It used to be, prior to, if you wanted to work at a really prestigious hotel bar, it was just a really long internship program, and you started off hauling and chopping ice for them and cutting produce. And the level of product knowledge you had to have to operate in one of those bars was just through the roof compared to what we experience in most bars today."

At The Usual, Hensarling does a number of classic cocktails, and the bar is a sister to his other two—the more down-and-dirty Chat Room, which he describes as "smoky, divey with two-dollar beer" compared to The Usual, the second bar he opened three years ago. This one has everything fresh squeezed and very exact and has better ingredients, and all those things

combined. Then the Gold Standard is like the idea of a dive bar, like the Chat Room, "where you have the bartenders making simple mixed drinks and cheap margaritas with fresh-squeezed juice, with the process pared down with creative ingredients."

On the cocktail menu at The Usual, Hensarling said, they try to keep a balance with classic style and some more of the current cocktail trends too. For example, he said, "The Bee's Knees, that was a classic prior to prohibition—just gin, honey and lemon juice, and one of those real simple and beautiful drinks out there. The Old-Fashioned—obviously that dates back to the 1860s, and we do it in the old-fashioned style, and the Last Word was actually one of the few cocktails that was created in America during prohibition. And the Sidecar came around during prohibition, but it was created in France during prohibition by an American bartender."

Hensarling actually began his bar life as a bartender, but now, with three bars on his shoulder, he is so busy that he doesn't bartend too much anymore. Nevertheless, he still has his favorite drinks, depending on circumstances. "If I went into a bar today, I usually start off with, well, it is a test-case scenario, like if I don't know the bartender, but I just know they have a reputation, then I will say, 'Just give me an Old-Fashioned or a Manhattan' or something really simple, and then I will go from there. If I am walking into a bar, and I know I am dealing with a skilled bartender—like up in Boston—then it is like, 'All right, give me a Mai Tai.' I love a good Mai Tai or something simple like a gin and tonic sometimes too."

As for what he has on his own menu, he said that it runs the gamut, with classics like a Martinez and Chrysanthemum "the Chrysanthemum is an amazing drink," he added. "I just, on a bet, said I could sell a case of vermouth a week. I said I accept that challenge, and we do like two or three cases of dry vermouth a week. And the thing about that, too, from a bartender's perspective, it is great to get some stuff out there, and it is almost impossible to sell someone on dry vermouth because it has been so demonized in popular culture largely due to a marketing campaign that was run by Smirnoff. So, if you are getting dry vermouth and Benedictine and absinthe over the bar to customers, and they are just loving it, it is always like *hah*."

As far as the selection goes, the list at The Usual does change frequently. He said that he likes to keep a variety of spirits represented, like cognac, gin, whiskey and rum:

> *Gin was the thing, and again I want to represent a variety of spirits. Look at Vodka. That is more of a new thing than it was in the '40s when the*

Moscow Mule was invented, but prior to that, if you read bartending books prior to 1940, vodka was always one of the things that if it were a hotel bar and you have some Russian guests, you might want to keep a bottle of vodka. It was not until Smirnoff took off in the '50s—we do get a lot of requests for it, and there are some well-distilled—but everything we work with has a flavor, and that kind of sets it in a category of its own in how we approach using it. A lot of times, we blend it like in our drink the Unconventional Wisdom—that is made with vodka.

Hensarling started out as dishwasher at Little Caesars, then worked at Bennigan's on his way into the world of bartending and ownership, but he said that as far as the direction he has gone now, that began seven years ago when he took over the Chat Room. He was adamant, no matter what, about staying open and not closing early like so many bars do on a whim.

"So, eventually," he said, "I started dusting off these cocktail books, and I had been bartending for a long time. I was like, 'I need to know how to make like a Sidecar,' so I got out one of the old dusty cocktail books that was there, and I made a Sidebar. And then, just through persistence and breaking down what each ingredient does, eventually I was able to start making the proper Sidecar, and I realized that my customers liked that. And what started out as a downtime, bored hobby at the Chat Room eventually turned into this."

The name of his popular bar, The Usual, came easy enough. He said that he and his partner had five or six names and were pressed in the amount of time they had to register the name with the county, so he was trying to decide and narrowing down the names from the list. Then, on his way to the courthouse to do the paperwork, it dawned on him that "The Usual" would be really ironic.

Regarding the phrase "prohibition drinks" these days, Hensarling said:

Honestly, like any bartender views it, prohibition was an absolutely horrible, stupid thing basically that wrecked our profession. We used to be considered on par with chefs, and the government just ripped the rug out from underneath us, and now bartending is something you do to get through college. When you comes to terms like "bathtub gin" and "blind tiger," it's like catchy, but in all honesty, the products that were being made during prohibition, if not horrible tasting, were toxic. In distillation, the number one thing is that you have to remove the heads of the spirits like methyl

alcohol, and that is the stuff that makes you go blind. You know the term "that stuff will make you go blind" is in reference to really horrible stuff happening to people because of lack of regulation by the U.S. government in distillation practices.

Hensarling added that the phrase "bathtub gin" has made the gin industry, even today, "really have to fight for its place. And there are some beautiful gins out there, and I have nothing but respect for the product, but those terms make it more difficult for us to have a conversation with our customers because of the references to preconceived notions about different spirit categories or types of drinks. From the aspect of trying to get people on board to try more things—because I really think a lot of people would find these drinks interesting even though it might be outside of what they normally enjoy—those terms have made it difficult and have made marketing more difficult and internal communications harder, too."

ALEXANDER (1916)

A recipe from about 1916 appeared for this drink in Hugo Ensslin's *Recipes for Mixed Drinks*. One historian has traced this drink back to Rector's in New York, a premier pre-prohibition lobster palace where the bartender, Troy Alexander, was said to have created it for a dinner celebrating Phoebe Snow. She was a fictitious character used in an advertising campaign for the Delaware, Lackawanna & Western Railroad. The drink was white to match the traveling attire that Ms. Snow was said to be wearing while riding on a train.

1 oz. gin
½ oz. dark crème de cacao
½ oz. light crème de cacao
1 oz. heavy cream

Combine all ingredients in a mixing tin. Shake. Strain into a cocktail glass. Garnish with freshly grated nutmeg.

Aviation.

AVIATION (1916)

CHARLIE PAPACENO'S RECIPE

2 oz. gin
½ oz. lemon juice
½ oz. Luxardo maraschino liqueur

Shake with ice and strain into a chilled flute. Drizzle a teaspoon of Crème de Violet so that it drifts down into the cocktail, forming a lovely sky-blue tint. Garnish with a homemade maraschino cherry.

TYLER LOTT'S LAVENDER AVIATION

1½ oz. lavender-infused gin
¾ oz. Luxardo
maraschino liqueur
¼ oz. crème de violet
½ oz. lemon juice
3 dashes lavender bitters

Lavender Aviation.

BLUE MOON (1917)

A number of drink variations abound for this drink. The Blue Moon was mentioned in Crosby Gaige's *Cocktail Guide and Ladies' Companion* and also in Hugo Ensslin's earlier version, though using gin, Yvette, dry vermouth and orange bitters there.

2 oz. Plymouth gin
½ oz. Crème Yvette
½ oz. lemon juice

Add all ingredients to a mixing tin. Shake. Strain into a cocktail glass. Garnish with a lemon twist.

CHRYSANTHEMUM (1916)

This drink was created by a German bartender in New York in the early twentieth century, and it is mentioned in Hugo Ensslin's *Recipes for Mixed Drinks* in 1916 as well as Harry Craddock's *Savoy Cocktail Book* in the '30s.

2 oz. dry vermouth
1 oz. Benedictine

Rinse a coupe glass with absinthe. Stir in ingredients and add a lemon twist for garnish.

DUBONNET COCKTAIL (1914)

A red wine cocktail made with spicy herbs—we like this recipe already. This was used to mask the taste of the really bad gin being used. In most accounts, the Dubonnet Cocktail was first mentioned in about 1914 at the Blackstone in Chicago, and there were also links to the Pendennis Club, the gentleman's club in Louisville. A good drink and oh so simple.

1 oz. Dubonnet Rouge
1 oz. dry gin
1 dash orange bitters

Combine in ice shaker. Shake. Strain into martini glass and garnish with twist of lemon.

THE MODERN (1910)

TYLER LOTT'S RECIPE

1½ Plymouth Sloe gin
¼ lemon juice
¼ oz. simple syrup
1 dash of absinthe
1 dash orange bitters
torched orange peel

1919 (1919)

This is the year before national prohibition took hold in the United States. With a spiciness from the rye and a bend toward the botanicals from the Punt e Mes and Benedictine, it's a rich drink that is a reminder of how good it was in those days before prohibition.

¾ oz. rye whiskey
¾ oz. Old Monk rum
1 oz. Punt e Mes
½ oz. Benedictine
1 dash Mole bitters

Build all ingredients in an Old-Fashioned glass. Add ice. Stir.

PINK LADY (1911)

It's a gin, grenadine, lemon juice, sugar and egg white combo that has stood the test of time. The name is said to have been taken from the 1911 Broadway musical by Ivan Caryll of the same name. It was often made at the Southern Yacht Club during prohibition in New Orleans. It had an alias as the Pink Shimmy.

1½ oz. London dry gin
¾ oz. applejack
¾ oz. lemon juice

½ oz. grenadine
1 egg white

Add all ingredients to a mixing glass. Shake. Strain into a snifter. Garnish with a cherry.

SEELBACH (1917)

This drink was named after the Louisville, Kentucky hotel where it was created and uses bourbon, Cointreau and both Angostura and Peychaud's bitters.

1 oz. bourbon
½ oz. Cointreau
7 dashes Angostura bitters

7 dashes Peychaud's bitters
simple syrup
5 oz. champagne

Add first four ingredients into a mixing glass. Add simple syrup to taste. Shake. Strain into a Champagne flute. Top with Champagne. Garnish with orange zest.

STINGER (1917)

2¼ oz. Remy VS
¾ oz. white crème de menthe

Add ingredients to a mixing glass. Stir. Strain into a cocktail glass.

DRINKS FROM 1920 TO 1929

WITH CHARLIE PAPACENO
AND LOUISE OWENS

The Windmill Lounge started its life more than forty years ago as the Dutch Kitchen Diner and served late-night breakfast to many tipsy clients over the years. After brief stints as a taco stand and a sandwich shop, the building became the Windmill Lounge. Since 1992, Louise Owens and Charlie Papaceno have been holding the line serving cocktails in the classic style, as well as creating seasonal and original drinks. It was recognized as Best Bar and Best Cocktails in 2012 by the *Dallas Observer*.

Louise Owens begins the conversation about prohibition, noting that most of the drinks were created before or after prohibition. "The drinks are actually called pre-prohibition, and it is all the drinks that were in the *Savoy Cocktail Book* when it came back out after prohibition. During prohibition, it was not about creating cocktails. It was about booze as opposed to making cocktails, and there had been all these brilliant people before making drinks, and they all left for Europe."

Charlie Papaceno added:

> When prohibition went into effect, that is when you had all the bartenders going to Europe, and that is why you see things like Bar American. It means they made cocktails; Americans were the ones who really pioneered all the cocktails. There are a few drinks that came out during prohibition like the Last Word, which apparently was invented at the Detroit Athletic Club—they had a bar hidden in there somewhere. Most of the drinks predate prohibition, and they were using soda and stuff during prohibition, hiding

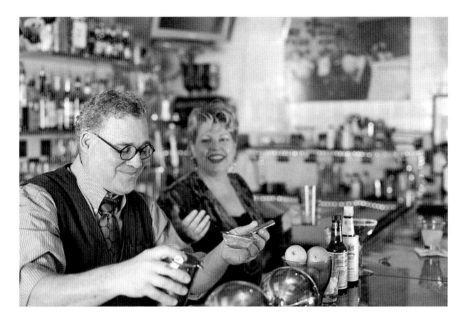

Charlie Papaceno and Louise Owens.

the flavor of cheap booze. They did tend to go toward a more stripped-down ingredient at the speakeasy too, like ginger ale, and you had all these bartenders using tons of fresh fruit and that sort of stuff.

Papaceno said that drinks from the Prohibition era are served at the Windmill Lounge. "As far as that kind of drink, we function on a dual level—a neighborhood bar where we have karaoke and such, and when people come in, they also recognize we do really well classic cocktails because we are using the original recipes as close as we can, and we try to keep the ingredients, which were important." At the bar, both Papaceno and Owens agreed that the top five drinks they serve are the Manhattan, the Old-Fashioned, the Aviation, a Sidecar and a gin drink, maybe a Last Word.

Owens then remembered the Sazerac, and Papaceno agreed. "This is one of the oldest drinks—I couldn't even give you the year because no one really knows, but it was originally made with brandy and then it changed to rye, but it has been around forever."

"At the Windmill Lounge, we use the standard recipes, maybe with some variations, but sometimes that drives me crazy," Owens added. "So we do our drinks pretty much exactly as they are supposed to be done—the original proportion. Like with Sazerac, we do it with rye now because that

is so popular, but it is the sugar cube and not simple syrup, for example. We don't try to fix things that are perfect."

"A lot of places try to make drinks that are proprietary to them, so it is our Sazerac, and you can only get that here," Papaceno said. "We are big on 'this is the way it was done and this is the way it should taste, so here it is.'"

Owens agreed that at the Windmill Lounge, they keep that philosophy that "these are the best recipes ever, and there are only a handful of drinks that have been invented in the last twenty years, like the Cosmo, for example. That started out as a great drink, and now it is disgusting, but when you look at it, of the twenty-five or so classic drinks, hardly anything has been invented in the last twenty years because vodka took over everything, and then people started doing shots. It was like the 'Craft of the Cocktail,' as Dale DeGroff called it, it has just got lost and everything was just vodka, vodka, vodka."

Papaceno added, "Now you have the flavored vodkas, and someone said the other day when we were talking about it that they remembered when you used to have to add the flavor yourself, and that meant real flavor and not what they are using now to put flavor into vodka"—apparently not a prohibition drink mindset.

"They used regular vodka because there was no citrus vodka back when the Cosmo was invented," Owens mentioned. "It was regular vodka and Cointreau and a splash of lime and some cranberry, and it was a great drink, but when you start adding forty-seven different sugared ingredients, then it is something pink and very sweet. I mean Cosmo is basically a margarita made with vodka or a Sidecar made with vodka, one of those sour drinks in that class."

Looking to past as well, Owens said in regard to how prohibition changed the way people look at drinks these days, "[It is] kind of like what is going on with marijuana right now. They realized it wasn't going to work, and a lot of people were interested in it and wanted to do it because it was illegal and fun, and the whole world was changing so rapidly at that time. It started when women were still wearing corsets, and it ended when women were wearing what I consider normal clothes. It was just a span of time when things were changing so much, and then to take away something that had been such a basic fabric of life in the middle of all these changes, it was phenomenal."

As Papaceno said, "There was also a big shift in what people drank, and a lot of the stuff that would come from Europe like brandy was not available. And before prohibition, Irish whiskey was the most popular whiskey in the United States. And then when prohibition came in, it was hard to get Irish whiskey, so people were using Canadian that came across the border, and I think probably bourbon went up in popularity, too, where it had not been before. It went up in popularity because it was easy to get it up from the South, legally or illegally."

As for what every person needs in their bar at home for a well-stocked cabinet, that would be, according to these two, bourbon, rye, gin, scotch, tequila and vodka, but you also need an aperitif, a digestive and the mixing tools. You have to have the standard well drink liquors first, and then you can branch out and also add to that either triple sec or Cointreau.

Barbary Coast (1920s)

The Barbary Coast was San Francisco's red-light district during the gold rush. How appropriate to name a drink after the place, right? Scotch and gin together, only during prohibition, would have seemed like a good idea.

¾ oz. blended scotch
¾ oz. gin
¾ oz. crème de cacao
¾ oz. heavy cream

Serve in a highball glass and combine with ice. Stir. Strain into a chilled cocktail glass.

Boulevardier (1927)

The Boulevardier was first found in a 1927 bar guide called *Barflies and Cocktails*. It was the signature drink of Erskine Gwynne, expatriate writer, socialite and nephew of railroad tycoon Alfred Vanderbilt. Gwynne also edited a monthly magazine named the *Boulevardier*.

1½ oz. bourbon
1 oz. Campari
1 oz. sweet vermouth

Stir long with ice in a mixing glass. Strain into a cocktail glass. Garnish with orange slice, lemon twist or cherry.

BLOOD AND SAND (1922)

¾ oz. Johnnie Walker Black
¾ sweet vermouth
¾ Cheery Heering
¾ orange juice

Add all ingredients to a mixing glass. Shake. Strain into a cocktail glass. Garnish with a flamed orange zest.

BLOODY MARY (1921)

Created in the 1920s, the Bloody Mary is said to have been invented by a bartender at the New York Bar in Paris (later Harry's New York Bar), but other stories suggest that it was invented in the 1930s at New York's 21 Club by a bartender named Henry Zbikiewicz. The name itself comes from the historical figure Queen Mary I of England, but some believe that it could have been named after Hollywood star Mary Pickford or even a waitress from Bucket of Blood, a bar in Chicago.

1½ oz. Russian Standard
4 oz. tomato juice
4 dashes Worcestershire sauce
1 dash celery salt
1 dash black pepper
½ oz. lemon juice
1 oz. Tawny Port
4 dashes Tabasco
½ a barspoon of horseradish

Add all ingredients to a mixing glass. Add ice. Roll in a Boston shaker to mix. Strain into a Pilsner glass. Top with ice. Garnish with three olives.

COLONY COCKTAIL (1920s)

First, let's say that New York's Colony was no ordinary speakeasy, as it was frequented by the likes of the Vanderbilts and the Windsors, who dined there. If there were drinks, then the bartender at the time just did as he was told. It is said that this drink was first made by the bartender Marco Hattem at the Colony Restaurant in New York City.

<div align="center">

1½ oz. gin
¾ oz. grapefruit juice
2 tsp. maraschino

</div>

Shake vigorously with cracked ice. Strain into chilled cocktail glass.

DOUGLAS FAIRBANKS (1920s)

The story goes that since Fairbanks's wife, Mary Pickford, had a drink named after her, so should he. He was a silent film icon after all. He asked a bartender in Cuba to give a cocktail his name.

<div align="center">

1½ oz. gin
1 oz. apricot liqueur
½ oz. lime juice
¾ oz. egg white (about half a large white egg)

</div>

French 75 (1920s)

This drink was named after a World War I artillery piece, a French-made seventy-five-millimeter Howitzer cannon, and the French 75 is, as far as can be found, the only cocktail invented in the United States during prohibition to become a classic. Shake well with cracked ice.

1 oz. London dry gin
½ oz. fresh-squeezed lemon juice
¾ oz. simple syrup

Combine ingredients in a mixing tin. Shake. Strain into a Champagne flute. Top with chilled champagne. Garnish with a peel of an entire lemon.

Hemingway Daiquiri (1921)

This particular drink, named after writer Ernest Hemingway, was invented in 1921 at the El Floridita in Havana. This daiquiri was served without sugar.

1½ oz. Bacardi Light
½ oz. Luxardo maraschino liqueur
1 oz. grapefruit juice
½ oz. lime juice

JACK ROSE (1920s)

This drink was said to be possibly named for a notorious gangster.

2 oz. Laird's applejack
¾ oz. grenadine
½ oz. lemon juice
1 dash Peychaud's bitters

Combine all ingredients in a mixing tin. Shake. Strain into a cocktail glass. Garnish with a lemon wheel.

LAST WORD (1922)

The Last Word cocktail is complex, made from gin and botanicals with a bit of herb flavor and the bittersweet taste of the maraschino. The drink is said to have been invented in 1922 at the Detroit Athletic Club by bartender Frank Fogarty.

¾ oz. gin
¾ oz. Luxardo maraschino liqueur
¾ oz. Green Chartreuse
¾ oz. lime juice

Add all ingredients to a mixing tin. Shake. Strain into a cocktail glass. Garnish with a cherry.

TYLER LOTT'S AGED BARREL LAST WORD

1 oz. Citadelle
1 oz. Luxardo maraschino liqueur
1 oz. Green Chartreuse

Age in a barrel for six months. Lemon juice should be added after aging.

Last Word, barrel-aged.

MARY PICKFORD (1920s)

Pickford was married to Douglas Fairbanks, and during prohibition, she was at the pinnacle of success, so of course a drink would have been named after her. This one has a Cuban spin since drinking was legal there during the Prohibition era.

1½ oz. white rum
1 oz. unsweetened pineapple juice
½ tsp. grenadine

Stir well with cracked ice. Strain into a chilled cocktail glass. Drop in a maraschino cherry.

TYLER LOTT'S RECIPE

2 oz. light rum
2 oz. fresh pineapple juice

1 tsp. house-made grenadine
1 tsp. Luxardo maraschino liqueur

MONKEY GLAND (1920)

A strange name indeed, this drink was supposedly invented by Harry McElhone, owner of Harry's New York Bar in Paris.

1½ oz. gin
1½ oz. fresh orange juice
1 tsp. grenadine

1 tsp. simple syrup
1 tsp. absinthe

Combine ingredients in cocktail shaker with ice. Shake. Strain into a cocktail glass. Garnish with an orange zest.

NEGRONI (1925)

1 oz. Beefeater
1 oz. Campari
1 oz. sweet vermouth

Combine all ingredients in an Old-Fashioned glass. Add ice. Stir. Garnish with a flamed orange zest.

PEGU CLUB (1927)

The Pegu Club recipe was said to have first surfaced in about 1927. It was perhaps created by bartender Harry Craddock, a famous American bartender who left the States for London during prohibition. Supposedly, the drink was named after the Pegu Club, which was a bar in Rangoon that British and foreign military brass frequented for drinks.

2 oz. London dry gin
¾ oz. Orange Curaçao
¾ oz. lime juice
1 dash Angostura bitters
1 dash orange bitters

Combine all ingredients to a mixing glass. Shake. Strain into a chilled cocktail glass. Garnish with a lime wheel.

Pisco Sour (1920)

2 oz. Pisco
¾ oz. simple syrup
¾ lime juice
1 egg white

*Add all ingredients to a mixing tin. Dry shake.
Add ice. Shake. Strain into an Old-Fashioned
glass. Garnish with a couple of drops of
Angostura bitters.*

Curtis Cheney's Recipe

2 oz. Pisco
¾ oz. fresh lime juice
¾ oz. simple syrup
one egg white

*Combine all ingredients into shaker tin filled with ice and shake for 10 to 15 seconds. Pour
into ice-filled Collins glass and add 5 to 7 drops of Angostura bitters and a lime wedge.*

Planter's Punch (1920s)

This was the kind of drink that was popular during prohibition and was
synonymous with the likes of rum heists from Mexico, Cuba and Puerto
Rico. A rum-based drink from the South, it was served at many speakeasies
in New York too.

2 oz. dark rum
¼ oz. grenadine
equal parts sour mix and either pineapple or orange juice
club soda (optional)
maraschino cherry for garnish
lemon or orange slice for garnish

SCOFFLAW (1924)

This cocktail was invented in 1924 at Harry's New York Bar in Paris and has much the same origin as the 12-Mile Limit. It is said that when a member of the Anti-Saloon League proposed a contest for a new way to talk trash about the evildoing drinkers of the time, the term "scofflaw" was invented. The drink of the same name followed.

1 oz. whiskey
1 oz. dry vermouth
¾ oz. grenadine
dash of Angostura bitters

Stir ingredients over ice. Strain into cocktail glass. Garnish with an orange twist.

SIDECAR (1922)

It's stiff and made with cognac, Cointreau and lemon juice in a 3:2:1 ratio that's shaken and served up. Said to be named for an army captain who liked to be driven to the bar in a motorcycle sidecar, it is perhaps the defining cocktail of the era.

CHARLIE PAPACENO'S RECIPE

2 oz. cognac
1 oz. Cointreau
1 oz. lemon juice

Shake well with ice and strain into a chilled cocktail glass. A nice variation is to rim the glass with lemon and then dip in sugar.

TYLER LOTT'S ROSEMARY FIG SIDECAR

2 oz. roasted fig and rosemary bourbon
1 oz. Cointreau
½ oz. lemon juice
lemon peel

SOUTHSIDE (1925)

Some call this drink a "prohibition gem," and it may have been the drink of choice for Al Capone and his bunch. Whatever the case, it is a gin-based drink with sugar, mint leaves, lemon juice and club soda, and some say that it comes from the South Side of Chicago and was created in hopes that the bad gin might taste better in this recipe. Of course, other stories say that this drink was made famous at the Manhattan speakeasy 21 Club and might have even been served at the South Side Sportsmen's Club on Long Island, a place known for its mint juleps.

2 oz. Fords Gin
6 to 8 fresh mint sprigs
¾ oz. simple syrup
1 oz. fresh lemon juice
splash of soda

Shake the ingredients and strain into a chilled cocktail coupe. Garnish with a mint leaf.

12-MILE LIMIT (1920s)

Named after the required limit for drinking offshore in America, the early drink of this name was the 3-Mile Limit, and it is a fun look at how folks found ways to snub prohibition.

1 oz. white rum
½ oz. rye whiskey
½ oz. brandy
½ oz. grenadine
½ oz. fresh lemon juice

Shake in an iced cocktail shaker. Strain into a cocktail glass.

WHITE LADY (1929)

It was said that a bartender by the name of Harry Craddock mixed the last legal drink before prohibition became the law in New York. Then he

went off and became the bartender of the Savoy in London. While there, he wrote a cocktail book of epic proportions and mentioned the White Lady, now a big part of the popularity of the famous hotel bar in London.

CHARLIE PAPACENO'S RECIPE

2 oz. London dry gin
1 oz. Cointreau
1 oz. lemon juice
egg white (optional, but delightful)

Shake well with ice and strain into a chilled cocktail glass.

WE DARE YOU: BATHTUB GIN (1920S)

If you really want to know, bathtub gin did exist, and it was as popular as the big bands, the dancing girls and the gambling that also existed at the time.

To create your own bathtub gin (if you dare), combine equal parts water and strong grain alcohol in a container that can be sealed. During the 1920s, people mostly used the popular moonshine, but this was dangerous and illegal and probably still is in some parts. Since moonshine is so popular these days, use the modern kind or even a bottle of 100-proof vodka and add about ½ ounce of dried juniper berries and a dram (1/16 of an ounce) of orange or lemon peel per 750ml of liquid. Cover the jar and store it in a cool, dark place for about a week. Shake it every day. When you uncover the mixture, pass it through a strainer.

DRINKS FROM 1930 TO 1939

WITH CURTIS CHENEY

Curtis Cheney, a fourth-generation barman, started out by pointing out that "the term 'prohibition cocktail' is not entirely correct. The time before prohibition was the golden age of cocktails. During prohibition, there

were not many cocktails being made. Most professional bartenders left the country or changed jobs. The time after prohibition is when cocktails took a downturn. So we have pre-prohibition and post-prohibition cocktails. The term 'post-prohibition' is rarely used."

Cheney said that he came into bartending like many of his contemporaries—it was a temporary job to get himself through school. "It quickly became my passion," he said.

Curtis Cheney of Del Frisco's.

As the craft beer craze hit its peak in the mid- to late 1990s, I had to learn beer styles, flavor profiles and a little of beer history. The bug to learn had bitten. The beverage industry is driven by marketing—marketing departments are not above stretching a truth (or lie), so the industry is a jungle of stories, truths, half-truths, fibs, tall tales, assumptions and myth. Stories are built on top of each other for years if not decades until the fog of time has rendered these stories as truth. Getting to the truth can be difficult. So, as the beer craze died down along with the century, my focus turned to spirits and cocktails.

He asked questions. "What was bourbon made from?" "What are the proportions of a Manhattan?" "Do you stir or shake a martini?" This thirst for this knowledge would not yield.

This drive eventually led me to take the Beverage Alcohol Resource Exam in New York City in 2009. It's a five-day, twelve- to fourteen-hours-a-day course where they cram more knowledge in your head than you ever dreamed of learning in a college-type of course. Once I understood that cocktails have a history that is not mutually exclusive from the history and culture of the United States—they reflect the times, mood and the culture from whence they came—then my interest really blossomed.

Cheney also talked about what he has learned during his research in regard to prohibition in DFW and how it differs from other parts of the country:

We have a bunch of Baptists here that publicly say one thing and personally practice another here in north Texas. Drinking was very much underground for decades, and with the dry areas now just being eliminated, the last restrictive policies of prohibition are just now leaving after over ninety years. We may want to wave the flag and pound our chest here in north Texas, but when it came to drinking, we can be very prude. In other parts of the country, even in other parts of Texas, the public approach to drinking is much more level-headed and pragmatic. So when you look at the drinking culture here in Dallas/Fort Worth, it was behind closed doors, in barns and garages. It separated those that imbibed from those that refrained, which is ironic considering one of the latent effects of drinking is the sociability of the whole affair. It segmented society, which is something that should always be avoided.

While he said that he has not found any specific drinks invented in the Dallas/Fort Worth area during prohibition or pre-prohibition that stand

out, he did note, "I think the drink that best represents the area would be the margarita. It has been in the Texas culture for generations, while just hitting the rest of the United States, relatively speaking. Tequila is part of the cultural fabric of Dallas/Fort Worth, and we have been consuming the stuff since grandpa was around."

As for his take on the five most popular drinks from the Prohibition era, he said that honors go to the martini (gin, not vodka); a whiskey sour (mainly Canadian whisky); tequila, with whatever cordial or sweetener that can be found; margarita, "in some form or dysfunctional fashion"; and the Mexican brandy in the form of a Sidecar, Sour or Fizz—this list not being in any particular order.

With the recent craze for mixologists/bartenders to mix Prohibition era drinks at the bar, Cheney said that he believes that these types of drinks have gained in popularity over the last few years

for the same reason that my grandchildren will jam out to Led Zeppelin, that we all know Mozart and that French fries will be served on plates for years to come: they are classic. They stand the test of time and bridge the river of ever-changing tastes and preferences. That's why the classic drinks are making a comeback. They are time-tested, unlike the sugar bomb shooters of the '90s that somehow morphed into the martini class the following decade. The reason the cocktail/bar world has seen a resurgence of late is part of the flavor revolution that was started in earnest by Julia Child. She showed America that you did not have to cook dinners from frozen vegetables and canned meat, that when you use fresh ingredients and proper technique, you get something that had been missing from the American plate since World War II: flavor. The production and packaging of food after World War II was geared towards preservation and shipping viability rather than nutritional content and flavor. Julia showed America that you can make chicken cordon bleu in your home without ever having to travel to France, that a well-made dinner could be had without using a can opener. The flavor revolution continued as the restaurant landscape saw ethnic restaurants move from the immigrant neighborhoods of the city to the suburbs, then to franchise across the country. The craft beer got its start in San Francisco with Anchor Brewing Co. and hit its stride, only to stumble in the late 1990s.

In the last three years, the craft beer segment not only has made a comeback but has carved out market share that very few in the industry expect to recede anytime soon. Why? Because the consumer wants flavor. Light beer has no flavor, neither does a vodka soda. Oversweetened drinks that mask alcohol and aid in massive hangovers

had been the mainstay of bartenders ever since prohibition, when all the trained bartenders had changed vocations or traveled outside of the U.S. to ply their craft. As the flavor revolution maintained its creep across the American culinary landscape, the willingness for the consumer to taste cocktails that had not been consumed on a large scale in over one hundred years increased. Old recipes were dug up, spirits that had been regulated to forgotten shelves were rediscovered and bartenders started to relearn techniques and methods.

As for the impact that prohibition had on the drinking scene overall in the Dallas/Fort Worth area and the country overall, Cheney added that

for all intents and purposes, it killed the drinking scene. Alcohol would be regarded as evil and treated as such for many decades after the repeal of prohibition, mainly due to the blue laws that prevented you from not only buying alcohol in large swaths of areas, but the purchase of a hammer and nails were prohibited as to not offend God. I never understood the connection with God and not drinking, considering that some scholars have postulated that if it wasn't for the Christian monks distilling during Middle Ages, they very well might not have lasted as long as they did. The monks would use the distillates to purify the drinking water, enabling them to live to the ripe ol' age of thirty-five to carry on the knowledge of the Greeks, Romans, etc. So for as much of a social bane of distress it seems alcohol can be, it might have just prevented us, in part, from living like its 1813. Thankfully, we don't have to consume alcohol as a means of cleaning the water—today it's daiquiris, Manhattans and Old-Fashions. But the attitude here in north Texas is changing

CURTIS CHENEY'S MUSTS FOR
EVERY GOOD BAR

- tequila, rum, bourbon/ rye and gin should be represented
- drinks that are both up and on the rocks
- fresh juice, not out of a can
- drinks should offer a variance in level of sweetness
- drinks should use the best spirits and not the ones from a single producer/ distributor

for the better when it comes to the drinking scene. People want to drink better, and they are open to trying new spirits and cocktails. I used to make one Old-Fashion a month when I first started bartending in 1995. Now I make five to ten a night.

Finally, in regard to phrases like "bathtub gin," "speakeasies" and "blind tigers," when Cheney hears these terms, he said, "I think the speakeasy gets a very romantic page in history. Secret high-class clubs with doormen demanding pass codes behind secret passages sounds great and all, but here in Dallas/Fort Worth, let's be honest, it was more like a bunch of buddies drinking in a barn or above a garage in Highland Park. I could see people being served a tipple in a coffee cup at a restaurant or diner, but for the grandiose imagery of a speakeasy here in the area, I doubt it existed in all its glory. But I wasn't there, so who knows. As for bathtub gin, well, that just makes me think of poorly made hooch."

Alamagoozlum (1939)

The Alamagoozlum cocktail was first mentioned in a book by Charles Baker in 1939 and was said to be creation of the banker J.P. Morgan. Certainly a tongue twister to order, if it was good enough for Morgan, it is certainly worth a try.

1 oz. Genever
¾ oz. Jamaican rum
¾ oz. Green Chartreuse
¼ oz. Orange Curaçao
¼ oz. Angostura bitters
1 oz. water
¼ egg white
¾ oz. Gomme syrup

This drink recipe is half of the original, as the drink was intended to be served two at a time. Add all the ingredients to a mixing glass. Shake. Strain into a cocktail glass.

ALASKA (1930)

The drink appeared in the 1930s, but the name is a mystery even to cocktail experts. A simple recipe of gin, yellow Chartreuse and orange bitters, some bartenders use a floral gin for an herbal taste.

2½ oz. Old Tom gin
½ oz. Yellow Chartreuse
3 dashes orange bitters

Add all ingredients to a mixing tin. Stir. Strain into a cocktail glass.

BACARDI COCKTAIL (1937)

Quite popular in Havana, Cuba, during prohibition, the Bacardi Cocktail was the drink of choice for many who could get out of the United States for a really good drink.

½ oz. lime juice ½ tsp. granulated sugar
3 dashes grenadine 1½ oz. Bacardi rum

Mix thoroughly and shake well in cracked ice. Served strained or unstrained.

CREOLE COCKTAIL (1939)

Using bourbon and vermouth, this cocktail is a twist on the Manhattan, and it is the Benedictine that stands out here, bringing in an herbal flavor.

2½ oz. bourbon splash of Benedictine
I oz. sweet vermouth splash of maraschino liqueur

Pour ingredients into a mixing glass with ice cubes. Stir. Strain into a chilled cocktail glass.
Garnish with lemon twist.

MARGARITA (1933)

1½ oz. El Jimador 1 oz. lime juice
¾ oz. Cointreau ½ oz. simple syrup

Combine all ingredients in a mixing tin. Strain into a salt-rimmed Collins glass. Top with ice. Garnish with a lime.

THE PROHIBITION (1930s)

This is a classic cocktail recipe deemed as *the* prohibition cocktail. It was made popular in the *Savoy Cocktail Book*, published in 1933.

TYLER LOTT'S RECIPE

1 oz. Damrak gin
1 oz. Kina Lillet
¼ oz. lemon juice
¼ oz. apricot brandy

REMEMBER THE MAINE (1933)

This drink offers a mix of rye, with complex tastes from the Cherry Heering and a dash of absinthe.

1½ oz. Rittenhouse rye whiskey
¾ oz. Dubonnet
¼ oz. Cherry Heering
1 bar spoon Herbsaint

Combine all ingredients in a mixing glass. Stir. Strain into a cocktail glass. Garnish with a lemon twist.

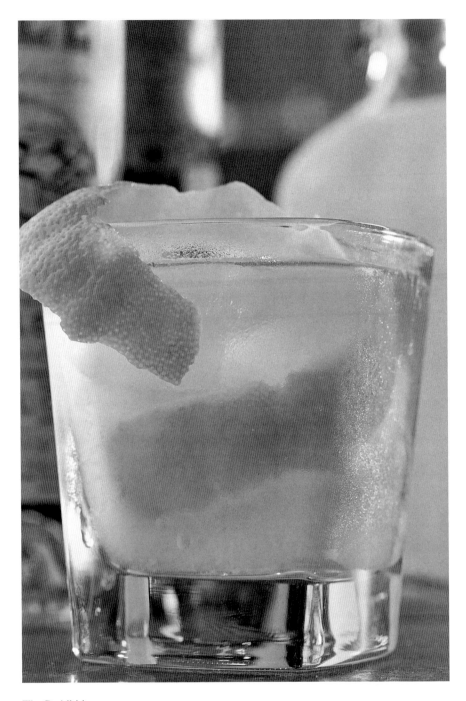

The Prohibition.

TWENTIETH CENTURY (1937)

Created by British bartender C.A. Tuck, this drink was named after a train called the Twentieth Century Limited, which ran between New York City and Chicago from 1902 until 1967.

1½ oz. London dry gin
½ oz. Lillet
½ oz. light crème de cacao
½ oz. lemon juice

Add all ingredients to a mixing tin. Shake. Strain into a cocktail glass. Garnish with a lemon twist.

VIEUX CARRE (1938)

A favorite at the Carousel Bar at the Hotel Monteleone in New Orleans, where it was said to have been invented by a man named Walter Bergeron, who was the head bartender at this bar at the time. It is named after the French Quarter (Vieux Carré, or "Old Square").

¾ oz. rye whiskey
¾ oz. cognac
¾ oz. sweet vermouth
¼ oz. Benedictine
2 dashes Angostura bitters
2 dashes Peychaud's bitters

Combine all ingredients in an Old-Fashioned glass. Add ice. Stir. Garnish with a maraschino cherry.

DRINKS FROM 1940 TO 1949

WITH MICHAEL MARTENSEN

Michael Martensen is the barman/proprietor at the Cedars Social in Dallas, and he said that making a particular classic got him interested in prohibition cocktails: "The first time that I made a proper Old-Fashion was when I knew that I wanted to start looking more into classic cocktails. The simplicity of the drink and the balance of the cocktail grabbed me right away. Once you really start understanding the basic cocktails, then you can really do whatever you like—really taking on those modern interpretations on classic drinks."

Martensen said that the number of ingredients that "we as bartenders can get our hands on in a regular day" is mind-blowing, but he added that this is what makes cocktails so fun. "At one time, bartenders had to be very creative in how they used their ingredients. Sometimes they only had mint, so what did you make? Juleps of course." Martensen's luck in finding information regarding prohibition in DFW and how it differed from other parts of the country was slim.

"Prohibition in Dallas did happen, as it did all over the country. From what I can read, it wasn't governed as hard as other parts of the country," he explained. "The Hotel Adolphus was opened up during that time by the Busch family, the family that owns Budweiser. The reason they opened the hotel was to have a hidden distribution point for the South. Also, downtown Dallas had Commerce Street. It was really the street where there were saloons, brothels and other clubs, and they were raided during prohibition."

Michael Martensen.

Martensen also said that from the research he has done, there were not any drinks specifically invented in the DFW area during prohibition or pre-prohibition. Although, he said, "drinks were being created every day…documentation was not happening. I am sure Dallas has many drinks that came from it. There were, in Texas, close to forty-three breweries, and when prohibition happened, these breweries were all legally shut down."

Martensen noted that he believes that these days, mixologists/bartenders are looking to Prohibition era drinks at their bars because back then, "drinks were made right. Fresh juice and produce, and the bartenders cared. The better the drink, the busier the bar. Alcohol was not being distilled the best, so the bartenders had to truly doctor what they gave the guests. Now, modern times, we have good spirits, but everyone started using powdered sweet and sour mix. It has come full circle, and patrons now have the best of both worlds—good spirits being made with fresh juice and by people who care."

As his most popular drinks from the earlier era, Martensen named the Mary Pickford, martini, Southside, Sidecar and the Bee's Knees. During the time, Martensen said, of course prohibition had an effect on the drinking scene overall and in the DFW area too. "Everyone had to close their bars down and go into

MICHAEL MARTENSEN'S FIVE
MUSTS FOR EVERY BAR

- *Bloody Mary*
- *Tom Collins*
- *Old-Fashioned*
- *Mint Julep*
- *Manhattan*

hiding. All this, too, during the Roaring Twenties, when the country was changing every day. As for Dallas, I am sure it was impacted just like the rest of the country."

Martensen first began his bartending career on the East Coast, where he says he was working at Toppers at the Wauwinet.

A gorgeous place, and I was kind of the guy that did everything on the property. One day, I had to fill in as the bartender. It was great. I had five seats and the entire restaurant to make cocktails for, and it was a blast. I then started to pick up shifts on the regular. We did things right at the bar, like fresh juice and produce, and we worked hard on a cocktail menu every month. It was the perfect balance for me. I could use any ingredient that I wanted as long as my costs were in order. From there, I moved around, then took the job at the Mansion on Turtle Creek as lead barman. It was the best stage anyone could ask for, with well-traveled guests and a beautiful room. Dallas was ready for the cocktail. The bar was getting a lot of press for the drinks we were making, and we were busy, too, and that was all in all a great combination. From there, I started working for Diageo, the world's largest spirits supplier. I was doing education all over the country for them on how to mix proper drinks using their brands. It was amazing. I got to see some of the best bars in the world and work alongside with them. I then met Brian Williams during that stint, and we started working on the Cedars Social. It was great, and I was able to take what I saw around the country and adapt it to Dallas. I believe that is why Cedars is a success. There is something for everyone. Now we are onto our next chapter and getting ready to open the Establishment, Dallas's first reservation bar.

Finally, when Martensen thinks of phrases like "bathtub gin," "speakeasies" and "blind tigers," he said that they make him think of "the American dream, really. The country was founded on the idea of freedom, and this is what Americans had to do during times of prohibition. They had to create the gin and establishments that you can partake in having a drink in. And Americans have always liked to socialize, and with socializing comes a drink or two."

BLACK RUSSIAN (1940s)

This drink is said to have been created in the 1940s when the American ambassador to Luxembourg was visiting the bar at the Hotel Metropole in Brussels. The bartender there, a man named Gustave Tops, decided to make a signature drink for the ambassador, and the Black Russian was born—a dark, mysterious drink using Russian vodka with Kahlúa. Later, the drink took on a different look when an unnamed bartender added milk or cream to create the sister White Russian in the 1960s.

1 oz. vodka
1 oz. Kahlua

Combine ingredients in an Old-Fashioned glass. Add ice. Stir.

THE BUCK

Created by Dallas mixologist Michael Martensen, this is a bit of a take on the Moscow Mule and is part of a family of historic drinks that use ginger ale, ginger beer and citrus juice as main ingredients.

The Buck has also been referred to as the Rum Buck, the Shanghai Buck, the Jamaica Buck or the Barbados, and if you add a Dark 'n' Stormy, you get the Rum Buck variation. It is the Vodka Buck that makes the Moscow Mule. In some creations, Ole Smoky Cherries is also yet another variation.

DARK 'N' STORMY

2 oz. rum
8 oz. ginger beer

Pour rum over ice. Add ginger beer. Stir.

MOSCOW MULE (1941)

1½ oz. Russian Standard
½ oz. lime juice
¼ oz. simple syrup
2 dashes Angostura bitters

Build ingredients in a Pilsner glass. Add ice. Top with ginger beer.
Garnish with a lime wheel.

MAI TAI (1944)

2 oz. aged rum
1 oz. lime juice
½ oz. Orange Curaçao
¼ oz. simple syrup

Add ingredients to a mixing glass. Shake. Strain into a Collins glass. Top with ice.
Garnish with a mint sprig lime wedge.

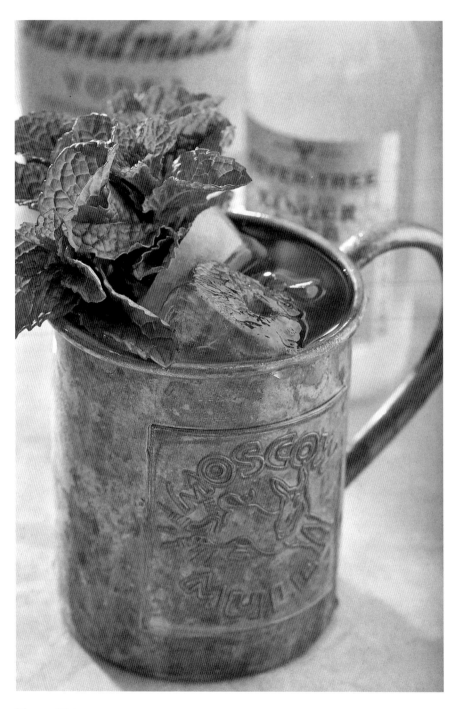

Moscow Mule.

SINGAPORE SLING (1940s)

1½ oz. gin
½ oz. Cointreau
¼ oz. Cherry Heering
¼ oz. Benedictine
1½ oz. pineapple juice
¼ oz. grenadine
2 dashes Angostura bitters

*Build ingredients in a Pilsner glass. Top with ice
and soda. Garnish with a lemon zest and cherry.*

SINGAPORE SLING (VARIATION)

¾ oz. London dry gin
¾ oz. kirschwasser
¾ oz. Benedictine

*Add ingredients to a Collins glass. Top with ice and soda. Stir. Add soda water to taste.
Garnish with a lime zest.*

FROM PROHIBITION TO THE MARGARITA MACHINE IN DALLAS/FORT WORTH

Mariano Martinez was born in Dallas in an area known as Little Mexico. Spanish was his first language, but when he turned five years old, his family moved into the Lakewood area, and here he learned to speak English, later playing electric bass guitar for Dallas rock band the Nightcaps. However, even with his many accolades, Martinez will forever be known for his invention of the margarita machine. Before opening Mariano's Mexican Cuisine, he got from his father a secret blended margarita recipe for the purpose of adding it to the restaurant's cocktail menu, and even today, his restaurants have the best margaritas in Texas, but what does all that have to do with prohibition? Here is what Mariano has to say about it.

What's your take on how DFW was during prohibition? Any family stories?

Having grown up in the restaurant business in the 1950s and '60s, there was still a lot of drinking going on. We were still allowed to sell beer and wine, and people were still allowed to bring in liquor in a brown bag.

I was just a teenager as a server, and I saw people still drinking. In addition to brown bags, people would bring in a souvenir bottle of tequila from Mexico, not knowing what to do with it. They would show my dad the bottle and say, "Our neighbors brought this back from Mexico…how do you drink this?" Nobody knew what to do with it or how to drink it. My dad would make margaritas in a blender with ice, and the atmosphere in the restaurant

Mariano Martinez. *Jeffrey Yarbrough.*

would be incredible, with people enjoying themselves and the company. That's when I knew there was magic in that bottle. He wouldn't make them every day. It was occasional, and he didn't charge for it. People still loved to drink, so they did.

People were already making margaritas at that time. Some say that the margarita is simply a spin on a drink called the Daisy, which was a popular drink during prohibition made with brandy, fresh lime juice and Cointreau. "Margarita" is Spanish for daisy, and it is the same drink, but with tequila instead of brandy. Supposedly, it became popular when people traveled across the border to Mexico for liquor. I've also heard it was made by mistake when a bartender grabbed a bottle of tequila instead of brandy because bottles weren't labeled back then. Supposedly, he said it tasted pretty good and called it a margarita.

How do you feel drinks have progressed over the years since prohibition? Does the margarita machine have anything to do with that? Why?

Drinks are much more sophisticated and complex. We have real bartenders that have to know how to mix drinks. During prohibition, people did not mix drinks much because the popular drinks were easy to make with brown liquors and Coke. Now you've got infusions and complex ingredients. Cocktails are an algorithm, like baking with precise ingredients. Mixologists have to have a feel for the balance. I dropped out of high school, but I made straight As in math and was good in music. Music is just another algorithm, so I think that's why I'm so good at mixing drinks.

The bartender I originally hired threatened to go back to his old place of business before we had the machine. The drinks were too hard to make. Today, cocktails, like food, are made with fresh ingredients. The kitchen and the bar staff intermingle with one another now, with the kitchen staff squeezing fresh juices, making garnishes, pureeing fruits and more. The bartender and the chef collaborate to create new flavors, combining the kitchen and the bar.

How do you think your machine affected drinking after the 1971 "Liquor by the Drink" law passed?

It had a major impact. The attributes of the machine, like its consistency (an elusive thing in the restaurant industry), allowed margaritas to be of consistent quality. They were very fast and easy to make.

It "wholesomized" drinking. Drinking margaritas is fun and something you and I would enjoy drinking at lunch versus drinking hard liquor like bourbon or scotch. It's a very simple and fun drink that lightens everything up. It made drinking fun without getting drunk.

Mexican food is expected to be inexpensive, and sometimes the difference between staying open or closing your doors can be the sale of drinks. More restaurants were able to open up and stay in business because of the machine. A "mom and pop" could serve margaritas without a skilled bartender on the payroll, so it helped make a difference between restaurants that survived or closed.

Do you think it changed the way people drink? How so?

We've read research done by Pace University's Lubin School of Business that found a correlation between women going into the workplace and women going to happy hour. The most popular happy hours during 1971–73 were at Mexican restaurants. Typically, people went to Tex-Mex restaurants just for a good bite to eat, but the margarita made the bar the center of Tex-Mex restaurants, and women preferred to go there versus bars and taverns dominated by men. Women could get inexpensive margaritas and free chips and salsa. A margarita was $1.25 and only $0.75 during happy hour. It made a huge impact on individuals who weren't drinking before.

Give me a speakeasy story...

My father never bragged that he worked in a speakeasy. I presumed it from him. It was 1937. He was in San Antonio working in a bakery and as a server in a hotel restaurant, and after hours, he worked as a waiter in a bar to make ends meet. The bar was serving blended margaritas at that time. They made them in a blender by mixing tequila, fresh lime juice, Cointreau and simple syrup. I don't think margaritas were invented in that bar, but I do know they were being served in 1937. Anyone who says margaritas were invented after 1937 is mistaken.

A LOOK AT PROHIBITION OUTSIDE THE DALLAS/ FORT WORTH AREA

Ask Colin Blake, the creative director for Flavorman and Moonshine University in Louisville, Kentucky, what he likes about teaching classes there, and he might first tell you that it's the history of prohibition that really gets his "Enthusiast" classes excited. Moonshine University is the educational division of Distilled Spirits Epicenter and offers a variety of classes for those with a passion for the craft of distilling and for the spirits themselves. Enthusiast classes devote two to three hours to one type of spirit, and there is also a five-day distiller course designed for entrepreneurs, industry professionals and those seeking careers in the distilling industry.

Blake said that he offered the class on prohibition on Repeal Day this year, and he opened by painting the portrait of what the country and the world was like in the early 1900s, as well as how the attitude of the time led to prohibition and why the country would vote it into law "when, in fact, we were practically in prohibition before prohibition was passed." He also teaches folks about many of the loopholes that the Volstead Act left and how people exploited them.

So where do you begin?

We evaluated two flights of spirits, gin and whiskey. Before each one, I showed a video of a local bartender and myself making both bathtub gin and whiskey from recipe. We had the bathtub gin and the whiskey in their corresponding flight and let people taste them against a couple name brands.

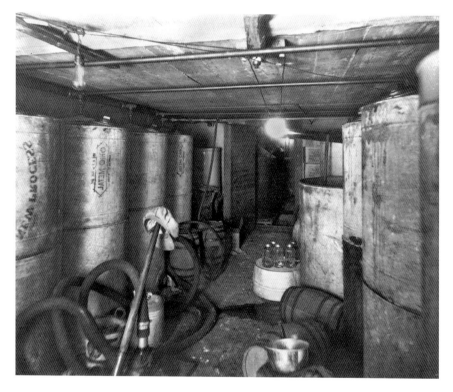

Stills during prohibition. *Dallas Public Library.*

I then told the rise-and-fall stories of three bootleggers: William McCoy, Roy Olmstead and George Remus. Each has an amazing story that, sadly, no one had even heard. Most hadn't even heard the names. There are so many amazing stories and characters with any area of history, but I feel the further away we get from them, the more reductive the history becomes. People have almost boiled the prohibition era down to "no alcohol," "speakeasies" and "Al Capone." I tried to put everything in perspective and paint a fuller picture. I saw surprise on the faces of a good amount of the class's attendees when they found out it wasn't illegal to drink during that time.

We gave everyone a tour of the distillery, which we luckily had running that night. And then I finished by talking about the social change that happened near the end of prohibition and why prohibition came to an end. Then I sent people out to celebrate the next day [that] they probably never heard of: the natural follow-up to Repeal Day, the National Hangover.

What was some of the most interesting information you found while researching prohibition?

The one thing that I really loved reading about, which was also hard not to make the class about it, was the fact that prohibition is an amazing time to study for women's history. Prohibition's rise and fall was really a women-driven movement, and it was during the first thirty years of the 1900s that women really started to come into their own.

My research also availed the fact to me that a lot of my favorite books from that era, and of all time, were mostly written abroad. But even though *The Great Gatsby* was mostly written in France, it was interesting to learn that Jay Gatsby was based on George Remus and that the two [Fitzgerald and Remus] were rumored to have met at Louisville's Seelbach Hotel.

How did different parts of the country differ in regard to prohibition, such as looking at Texas?

I originally wanted to make this the theme of the Repeal Day class—how the different areas of the United States got liquor, from whom and what was popular, but other than where the source of liquor came from, I didn't see a huge difference.

Were there any drinks specifically created during prohibition or pre-prohibition that stand out?

Pre-prohibition was definitely a heyday for cocktails, but the real standouts, for me, are the Old-Fashioned and the Manhattan, for no other reason than that they're still around and popular. Even though people might not find these drinks as exciting, it takes a hell of a cocktail to hang around for 150 years and still be a standard.

The only standout that I can really think of during prohibition is the Scofflaw. It was one of the few drinks that was created and became popular during prohibition, but as it was with many drinks of that era, it wasn't created in the United States. It was created in Harry's New York Bar in Paris. It was created to be able to toast the Americans who drank despite it making them criminals, to all the scofflaws in America. Americans traveling abroad brought the drink back with them, and it quickly gained popularity.

What are the five most popular drinks from this period in your opinion?

- French 75 (also invented at Harry's New York Bar)
- Old-Fashioned
- Manhattan
- Sazerac
- Sidecar

What was the alcohol used for drinks most of the time in the speakeasy?

Two biggest sources of alcohol produced in the United States were denatured alcohol—which was renatured so it could be consumed—and moonshine. It could be sold unto itself or made to taste like other spirits through recipes. The biggest external source was bootlegging, and the big three of those that were often bootlegged were whiskey, rum and gin. As to what were the most popular, I'd say whiskey and gin. They were the most popular spirits of the time. Rum was losing popularity, but people would drink what they could.

Why do you think that right now is a time when mixologists/bartenders are looking to Prohibition era drinks at their bars, and why have these drinks gained popularity over the last few years?

I think that it's a trend that started with scotch in the '80s and is slowly growing to all liquors and into cocktails now. In the '60s and '70s, clear neutral spirits were all the rage, mostly vodka and gin. They were almost never drank unto themselves, and the drinks that were made with them were sugary and sweet—no depth or complexity to them. And over time, the class and sophistication that sometimes went with drinking started to slip away—I don't know how ordering a Screaming Orgasm or Sex on the Beach wasn't classy, but I guess some people are more judgmental than I.

Then, in the '80s, scotch became popular, the variance in kinds, the different ages, the vast difference in taste from brand to brand, and the trend-setting yuppies loved being able to talk about it and knowing about it. Other liquors saw the trend, did some rebranding and inventing to match image, and other liquors started to become popular again. It's during the '80s that "single barrel" and "small batch" were invented for bourbons to ride the coattails of scotch's popularity.

People like to be, and come across as, educated about many things, and people also like to be social. Liquor allowed people to do both. Now you can go out and talk analytically about what you're doing while being social, drinking. But not everyone can drink spirits straight, so the natural extension is cocktails. And pre-prohibition and Prohibition era drinks are great and mostly forgotten, so a bartender bringing out the back stock to show off what they know is fun for bartenders to do and fun for customers to experience. Plus it's great marketing.

What kind of impact do you think prohibition had on the drinking scene in the country overall?

It was the best thing to happen to social drinking. First, it deregulated everything. With no regulations for bars, everything changed. There were no closing times. Bars got to make their own rules, and one of the big changes that happened is that bars changed from men's only saloons to coed establishments. Men and women were drinking together outside of the house en masse for the first time ever in the country.

Dallas prohibition. *Dallas Public Library.*

Secondly, it made drinking taboo. And if there's one thing that everyone knows, it's that people want what they are told they can't have. Prohibition added a mystique and allure to drinking that it had never had before.

I think H.L. Mencken said it best when Repeal Day came. As the entire country raised a glass of some spirit or alcohol to toast the end of prohibition, Mencken downed a glass of water and said, "That's the first water I've had in fourteen years."

BEYOND THE MARGARITA MACHINE

Campisi's restaurant is a staple in Dallas, and while the restaurant did not get started until after prohibition, many stories have been told about this restaurant over the years, and indeed there has always been a mysterious allure about the place that just reeks of prohibition-type tales.

According to the restaurant's website, Carlo "Papa" Campisi and Antonia came to New Orleans from Sicily in 1904, settling in Dallas. While they began with a grocery store at the corner of Hall Street and Central Expressway (formerly the Central tracks) in 1946, after World War II, Papa purchased a bar at the corner of Knox and McKinney called the Idle Hour. There was a kitchen, and that meant food. After a cousin from New York came to visit and suggested a pizza restaurant, of course Papa decided to do just that, creating Dallas's first pizza and Texas's first pizzeria.

In 1950, the location moved to Mockingbird Lane, where it still is today, over what was called the Egyptian Lounge. Since there was not enough money to buy a new sign, the original Egyptian sign was changed by removing "Lounge" and adding "Restaurant," and some folks still refer to it by its earlier name even today.

In 1971, Campisi's was granted one of the first liquor licenses in the state of Texas since prohibition. It was not until 1993 that the first satellite store was opened, expanding the brand. These days, there are a number of locations in the Dallas area.

Joe T. Garcia's: A Fort Worth Staple Since 1935

Opened in July 1935 in Fort Worth by Joe T. and Jesse ("Mamasuez") Garcia, this restaurant was opened as part of their home in Fort Worth. Situated in the front room of their house, the original restaurant had four tables and only seated sixteen people. Joe T., Jesse and their five children continued to live in the back part of the restaurant, and they decided to grow the family business by word-of-mouth tactics rather than advertising techniques. In the 1940s, the restaurant expanded to include a larger dining room and accommodate more people due to the demand for Joe T.'s authentic Mexican food. In 1953, Joe T. passed away, but Jesse and their youngest daughter, Hope, took over the restaurant and helped foster the growth of their bustling family business.

Like most Mexican food restaurants, Joe T. Garcia's most popular cocktail is the margarita. Unlike most Mexican food restaurants, however, Joe T.'s is rumored to use 190-proof Everclear in its cocktails to bring them from strong to industrial strength.

Epilogue

PROHIBITION LEGACIES

In closing, let's just face it and say that alcohol has been part of American life since the beginning of the colonies. While prohibition did indeed end in 1933, even today there are many trends that still survive from that time and definitely in the Dallas/Fort Worth area. Here are a few prohibition legacies that still live on:

- *temperance beliefs*: Activists from this movement might have thought that beer was a drink of moderation, but it was not really so. Did you know that beer, wine and liquor all have the same amount of alcohol (six-tenths of one ounce)?
- *blue laws*: Laws of this type began hundreds of years ago so that folks would respect Sunday as a day to go to church. Even today, fourteen states still maintain blue laws and prohibit the sale of distilled spirits on Sundays.
- *dry counties*: There are still many dry counties, and the Dallas/Fort Worth area still has many that restrict alcohol sales partially or completely.
- *root beer*: Root beer was a drink developed by temperance lovers, hoping that it would replace beer in popularity, but it didn't work.

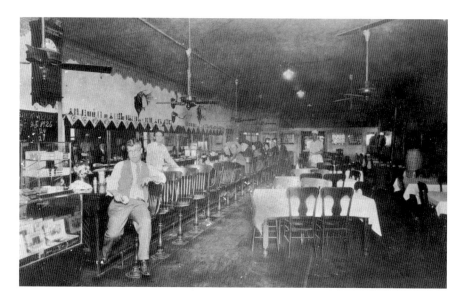

Maverick Saloon and Café, 1928. *North Fort Worth Historical Society.*

Elderflower Tickle.

Many will tell you that the time just before prohibition, from the 1890s to 1919, was the most wonderful "golden era" of the cocktail age. This might certainly be true, since most of the popular drinks still around today were created during that time. In closing, here is one more drink, contributed by Curtis Cheney and called the Elderflower Tickle. It is not from the golden era, but perhaps if Cheney had been around during that time, it would have been.

ELDERFLOWER TICKLE

2 oz. St. Germain
juice of ½ large lime (whole lime if small)
4 to 6 mint leaves

Put all contents into ice-filled shaker tin and shake vigorously for 10 seconds. Pour contents into chilled martini glass and top with a dry sparkling wine.

CLASSIC COCKTAILS LIST

Alamagoozlum (1939)

Alexander (1916)

Algonquin (1902)

Americano (1860s)

Aviation (1916)

Bacardi Cocktail (1937)

Barbary Coast (1920)

Bee's Knees (1874)

Bijou (1890)

Black Russian (1940s)

Blood and Sand (1922)

Bloody Mary (1921)

Blue Moon (1917)

Boulevardier (1927)

Brandy Crusta (1852)

Bronx Cocktail (1905)

Chrysanthemum (1916)

Clover Club (1880s)

Colony Cocktail (1920s)

Corpse Reviver (1900s)

Creole Cocktail (1939)

Daiquiri (1898)

Dark 'n' Stormy (1940s)

Deshler (1800s)

Dubonnet Cocktail (1914)

French 75 (1920s)

Gibson (1908)

Gimlit (1867)

Hemingway Daiquiri (1921)

Jack Rose (1920s)

Last Word (1922)

Mai Tai (1944)

Manhattan (1874)

Margarita (1933)

Martinez (1860s)

Martini (1880s)

Mary Pickford (1920s)

Mint Julep (1803)

The Modern (1930s)

Mojito (1890s)

Monkey Gland (1920)

Moscow Mule (1941)

Navy Sour (1870)

Negroni (1925)

Sazerac.

1919 (1919)
Old-Fashioned (1800s)
Pegu Club (1927)
Pimms Cup (1823)
Pink Lady (1911)
Pisco Sour (1920)
Planter's Punch (1920s)
Ramos Gin Fizz (1888)
Remember the Maine (1933)
Rickey (1833)
Rob Roy (1894)
Sazerac (1838)
Scofflaw (1924)
Seelbach (1917)
Sidecar (1922)
Singapore Sling (1940s)
Southside (1925)
Stinger (1917)
Tom Collins (1869)
12-Mile Limit (1920s)
Twentieth Century (1937)
Vieux Carré (1938)
Ward Eight (1898)
Whiskey Sour/Smash (1860s)
White Lady (1929)
Widow's Kiss (1895)

ABOUT THE BARTENDERS

CURTIS CHENEY

Curtis, a fourth-generation barman, has lived in the bar scene his entire life. He grew up in Chicago, Illinois, with summers in Wisconsin, and cut his teeth on a bar rail in his grandparents' North Woods supper club. He landed in north Texas in his early twenties and began an eighteen-year-long bartending career. He has worked at many top-selling Texas establishments—most notably Smith and Wollensky and Hibiscus—and he currently heads the bar at Del Frisco's Double Eagle Steak House in Fort Worth. He has handled beverage development for Del Frisco's Restaurant Group, which operates Del Frisco's Double Eagle Steak House and Sullivan's Steakhouse. His range wanders through the full spectrum of bar life. He has worked in the fast-paced nightclub scene and the high-volume beer hall and has dealt with the discriminating clientele of elegant, fine dining establishments.

In 2006, Curtis was sent to Switzerland to lecture on the American bar scene and the concepts of the cocktail. He has lectured at the Cordon Bleu Culinary Academy in Dallas and the University of North Texas in Denton. Curtis has written training material and developed educational programs for several different companies, as well as consulted on beverage programs for many different restaurants. He has held countless beer, wine and spirit tastings throughout the United States and has trained hundreds along the

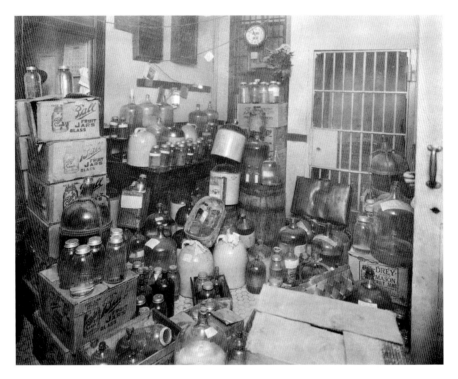

Alcoholic beverages during prohibition. *Frank Rogers Collection, Dallas Public Library.*

way as a corporate bar trainer for several hospitality companies. He passed the five-day Beverage Alcohol Resource (BAR) exam in 2010 with the higher degree of "Bar Ready." He is also a member of the Ultimate Cocktail Challenge judging panel in New York City.

BRAD HENSARLING

Brad Hensarling is the owner of not only The Usual in Fort Worth but also the Gold Standard and the Chat Room Pub.

Jason Kosmas

Jason Kosmas helped pioneer the classic cocktail movement in New York City with the opening of Employees Only and Macao Trading Co. For more than a decade, Jason has been an influential force in shaping drinking and nightlife as a bartender, restaurant owner, consultant and author. Jason currently resides in Dallas, Texas, where he is again championing cocktail culture as beverage director for Marquee Grill.

Kosmas began his professional restaurant career in New York City, working for restaurant mogul Keith McNally at Pravda in SoHo in the late 1990s, where he operated as bar manager. In 2003, he opened beverage consulting firm Cocktail Conceptions, whose nationwide body of work includes restaurants (Keith McNally and Jean-Georges), hotels (Bar Marmont, Standard and W Hotel) and major spirit conglomerates (Moet-Hennessey and Pernod-Ricard).

In 2004, Employees Only opened as an Art Deco speakeasy and cocktail bar. Drawing from a culinary approach to classic mixology, EO became a birthplace for contemporary cocktails, bringing the public closer to this almost forgotten craft. Macao Trading Co., Kosmas's second endeavor, opened at the end of 2008, celebrating the infamous Portuguese port in China. Here they were able use the crossroads of East and West in a groundbreaking direction, again using classic recipes, techniques and formulas.

In 2006, Jason Kosmas (with coauthor Dushan Zaric) released *You Didn't Hear It from Us*, a social commentary and dating guide for women from the bartender's perspective, published by Simon & Schuster. In 2010, Kosmas and Zaric released *Speakeasy: Classic Cocktails Reimagined from New York's Employees Only Bar*, which was nominated for Best Cocktail Book at Tales of the Cocktail in 2011.

Kosmas and Zaric would continue to expand the EO name in 2010 with the launch of Employees Only Crafted Bar Mixtures, bottling some of their prized homemade recipes and brining them to the home enthusiast. Currently, they are producing all-natural grenadine made from real pomegranates, cane sugar and spices, as well as their big and bold Bloody Mary mix. These bar ingredients are sold in the Northeast to bars, restaurants and specialty markets such as Whole Foods and Fair.

Jason moved to Dallas in 2009 and opened Neighborhood Services Tavern, where he was awarded Best Bartender in Dallas by *D Magazine* in 2010. Following that, Jason worked as bar manager for locavore restaurant Bolsa in

Oakcliff, creating contemporary cocktails with a focus on seasonality and local produce. Currently, Jason is the executive beverage director for Marquee Grill, working alongside Top Chef Tre Wilcox in Dallas's iconic Art Deco Highland Park Village Theater.

Kosmas's most recent endeavor is The 86 Co. Noise and Spirits. Together with other bar industry leaders, 86 has collaborated with some of the best distillers in the world to make vodka, gin, tequila and rum specifically designed for mixing in cocktails. These spirits can already be found in the most prestigious bars across the country.

With more than fifteen years behind the bar, Jason has demonstrated time and time again that he is able to make restaurant-bar concepts not only successful but also award winning. In 2001, Pravda was awarded Best Martini Bar by *Time Out New York* under his management and restructuring of the bar. In 2005, Employees Only received Best Classic Cocktail Bar by *New York Magazine* within its first year of opening. In 2007, readers of *City Search* voted EO the Best Cocktail Bar in New York City. Even after four years of being open, Employees Only was voted Best Bar in New York by readers of *New York Magazine* in 2009. Later that year, Kosmas was named one of the Best Bartenders in New York by *Forbes* magazine. In 2011, Employees Only took home the greatest honors for Best Drinks Selection and Best Cocktail Bar in the World at the Tales of the Cocktail. In 2012, Marquee Grill was listed as one of the top bars in the Southwest by *Food & Wine* magazine.

TYLER LOTT

For Tyler Lott, tending bar is more than slinging shots and pouring beer. It is an artistic expression. One sip of her clever cocktails, and it is obvious that she is on to something. Currently serving as lead bartender at Asador, a Dean James Max restaurant in the Renaissance Hotel in Dallas, Texas, Lott's creations perfectly complement the restaurant's philosophy of utilizing local and fresh ingredients to create farm-to-fire cuisine.

Though the young mixologist is self-taught, six years of experience and flawlessly executed cocktails prove that she knows her way around the bar. The one hundred fine tequilas may be the restaurant's most

notable collection of spirits, but there are other standouts. Lott noted the seasonally infused tequilas, vodkas and gins in addition to housemade bitters, simple syrups and purees. She uses these fresh and unique ingredients to carefully conceive cocktails that showcase both seasonal and industry trends. The result of her talent is an evolving cocktail menu that reflects both Asador and her own originality.

Lott's creativity stems from a passion for discovering new things. In her free time, she enjoys traveling and learning about new trends in the food and beverage industry. This natural curiosity, in addition to her strong work ethic, is the reason why this Texas native has made such a splash on the Dallas bar scene since her arrival in 2010. When asked about her personal philosophy, Lott admitted that she is a big believer in karma. To the delight of Asador's patrons, karma seems to be on her side. Though she modestly claimed to be working on her career highlight, it is clear that Lott's take on the art of the cocktail is not one to be ignored.

MICHAEL MARTENSEN

Michael Martensen is a bartender and proprietor who has transcended and redefined the art of the cocktail in Dallas. Currently serving as head barman at the Cedars Social, Martensen honed his craft working as the luxury spirits ambassador for Diageo and mixing cocktails at bars and restaurants across the nation, including Rosewood Mansion on Turtle Creek. This prodigious barman has transformed storied bars' cocktail programs by creating unparalleled cobblers, fixes, fizzes, puffs, sours and punches. His passion for unique flavor profiles, clever concoctions and whimsical presentations translates to quite an impressive cocktail list.

Michael is founding president of the North Texas Bartenders Guild and completed the reputable Beverage Alcohol Resource (BAR) educational program. During his time at the Cedars Social, Martensen has gained national acclamation and was recently honored as November Bartender of the Month by *Nightclub & Bar* magazine.

CHARLIE PAPACENO AND LOUISE OWENS

The Windmill Lounge started its life more than forty years ago as the Dutch Kitchen Diner and served late-night breakfast to many tipsy clients for more than four decades. After brief stints as a taco stand and a sandwich shop, the building became the Windmill Lounge. Since 1992, Louise Owens and Charlie Papaceno have been holding the line, serving cocktails in the classic style, as well as creating seasonal and original drinks. It was recognized as Best Bar and Best Cocktails in 2012 by the *Dallas Observer*.

ABOUT THE AUTHORS
AND PHOTOGRAPHER

Rita Cook is an award-winning writer/editor who specializes in writing on a variety of subjects, such as travel, which takes her around the world, but also cuisine and drinks, a topic she can research during her travels. With more than fifteen hundred articles to her credit in the past thirteen years and now nine books, Rita is the editor in chief of the *Insider Mag* and managing editor for *Celeb Staff* magazine. She started her career in Chicago working with well-known *Sun Times* columnist Irv Kupcinet.

She writes for the *Dallas Morning News* and *Focus Daily News* in the Dallas area and has worked with many national and regional publications over the years, including *Living* magazine, *Triple A*, *Four Seasons*, *Porthole*, *Valley Scene* magazine, *Traveler's Way*, *Dallas Child*, *Pegasus News* and Julib.com, to name a few. She currently has a weekly auto column called "Behind the Wheel" with the *Washington Times*

Communities and can be heard on the radio every Monday evening nationally on the *Anthony Duva Show*'s featured segment "I'm Standing Here."

Her published books include a romantic comedy titled *Angel's Destiny*, *The Complete Guide to Robert's Rules of Order Made Easy*, *Independent Producer's Survival Guide*, *A Brief History of Fort Worth*, *Haunted Dallas*, *Haunted Fort Worth* and *Haunted Bartlesville, Oklahoma*, the four latter released by The History Press.

She co-wrote with Russell Dandridge *Tourist Town Guides: Fredericksburg, Texas*. She has published a short e-book titled *How to Become an Independent Producer* and worked on the titles *How to Choose Golf Balls* and *Adult Students Financing an Education*, as well as ghostwrote a book called *Toasts and Vows*.

Before moving to Dallas in 2008, Cook lived in Los Angeles, where she was a well-known entertainment journalist, interviewing hundreds of celebrities and filmmakers, as well as producing a number of low-budget films. She was an associate producer on the horror/action feature film *Route 666* with Trimark Pictures and on *Naomi's Web*. She produced the feature-length film *Marty & Virginia* for Cicero Productions and served as a production manager on the television pilots for *Norm Crosby's Celebrity Golf Challenge*, *Two American Idiots* and *The Biz* with CRC Entertainment. She also worked on Duva Film's *Lost Soul* and *Creature from the Green Mist*, receiving producer credits on both.

Along with previously serving on the board of directors of Women in Film and Television/Chicago, Cook has been affiliated with the Northwestern University Screenwriting Seminars and the National Writers Union, where she served as treasurer for one year in Chicago and also for the Los Angeles chapter as treasurer. She was also vice-president of the Film Advisory Board in Los Angeles for six years.

She holds a BA in communications from Roosevelt University in Chicago, Illinois.

From his days as a roving restaurateur to his current work leading public relations and real estate clients to extensive accolades and booming business, Jeffrey Yarbrough has achieved unequivocal success in all aspects of the hospitality industry. How does he do it? An entrepreneur by nature, Yarbrough shares with his clients the real-life experience he gained from running his own businesses. Yarbrough's years of experience in the hospitality industry combined with his knowledge of media and public relations have warranted his bigInk PR and Marketing company receiving recognition as one of *Dallas Business Journal's* Top 25 public relations companies in Dallas/Fort Worth.

Yarbrough showed interest in running his own business from an early age. When he was only five years old, he picked plums from his grandmother's trees and sold them to neighbors. Yarbrough is a catalyst

for new concepts. Unique ideas he has initiated and promoted in Dallas, Fort Worth, Houston and elsewhere have received national acclaim for their financial and creative achievements.

His first entertainment accomplishment (Concept Nouveau Inc.) was Dallas's original four-clubs-in-one complex—including Art Bar, Blind Lemon, Club Clearview and Red. Its diverse club settings, friendly atmosphere and service, in addition to creative marketing campaigns, have made the complex a model for nightclub establishments throughout the nation.

Jeffrey's innovative entrepreneurial spirit led him to launch Liberty Noodles in 1998, the first pan-Asian noodle house located on Lower Greenville in Dallas, Texas. The whimsically chic restaurant received rave reviews, including one of the Top 10 Best New Restaurants from the *Dallas Morning News* and the Tastemaker Award for Best Ad Campaign. As if that wasn't enough, Yarbrough also co-wrote the nationally circulated *Complete Idiot's Guide to Asian Cooking* with Liberty Noodle's founding chef, Annie Wong.

In 2004, he took his knowledge of the hospitality industry and opened bigInk PR and Marketing, using his experience to help other restaurateurs and business owners reach sweeping success. In 2007, he expanded the company to include commercial real estate services, bigInk Real Estate, to support growing restaurant companies, serving both restaurateurs and real estate developers.

An expert networker, Yarbrough thrives through bigInk involvement in community and industry organizations. Continually inspiring his team to excel in their personal and professional lives, he serves as a mentor and offers opportunities to help them reach their goals. Yarbrough leads by example, not only in business but also in his ability to balance work with a busy family life as a husband and father of triplets.

S pending his formative years in Connecticut, Kevin Marple felt the massive pull and influence of Manhattan only a few miles away. Kevin created his first painting, a fantastical vision inspired by the movie *Star Wars*, at the age of eight, true to his constant immersion in pop culture. Later, he became "shipwrecked" in Dallas, staying connected to these visions via the fledgling universal language of the supersaturated, hypervisual world of music videos. These early influences yielded a dichotomy between the true urban experience and the extremely bourgeois suburban lifestyle that helped shape his artistic base. His subsequent creative evolution, in addition to receiving his BFA in photography, matured Kevin into the dynamic photographer that he is today.

Kevin's photographs have adorned the covers of numerous magazines. Regular requests from national publications fuel his desire to create captivating photographic iconography. Art directors for the past fifteen years have been hiring him to create provocative images for not only national but also international advertising campaigns that capture the imagination of the global marketplace. Most recently, his work for Monster.com won a golden Addy, which is just a prelude for a photographer who is also listed on the Internet Movie Database for being on both sides of the camera.

His clients have included Dr. Pepper/7-Up, Chili's, Samsung, Uniden, McDonald's, Bailey Banks & Biddle, Monster.com, Essilor, AMX, Four Seasons Hotels, Rosewood Hotels, Noble House Hotels & Resorts, Harrah's, Borden, Baylor Hospital System, Ruth's Chris Steak House, Ritz-Carlton Hotels, Dymatize and Stephen Arnold Music.

OTHER BOOKS WRITTEN BY RITA COOK

The History Press:
Haunted Bartlesville, Oklahoma
Haunted Fort Worth
Haunted Dallas
A Brief History of Fort Worth

Channel Lakes Publishing:
Tourist Town Guides; Fredericksburg, Texas

Publish America:
A Survival Guide for Independent Producers
Angel's Destiny (fiction)

Atlantic Publishing:
An Easy Guide to Understanding Robert's Rules of Order

OTHER BOOKS WRITTEN BY JEFFREY YARBROUGH

The Complete Idiot's Guide to Asian Cooking

Visit us at
www.historypress.net

. .

This title is also available as an e-book